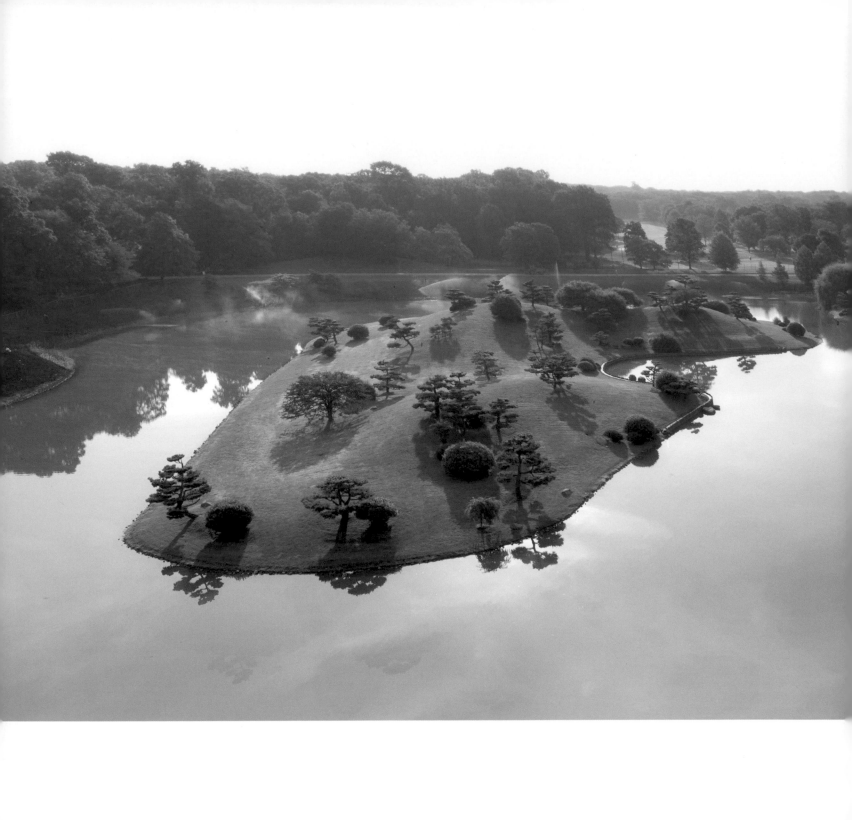

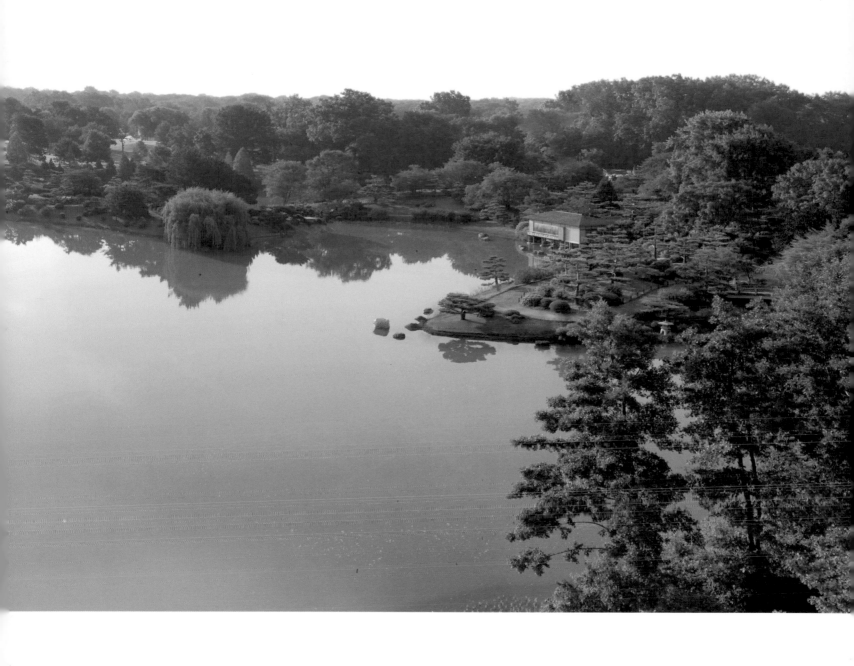

A JOURNEY TO
NINE ISLANDS

Chicago Botanic Garden

Project Team: Robin Carlson, Zina Castañuela,
Lee Randhava, Sophia Siskel, Deborah Starr

Design: Michael Motley, Santa Fe

Copyright 2007 Chicago Botanic Garden

First published in the United States of America
in 2007 by the Chicago Botanic Garden,
1000 Lake Cook Road, Glencoe, Illinois 60022.

The Chicago Botanic Garden is owned by the
Forest Preserve District of Cook County and
managed by the Chicago Horticultural Society.

ISBN: 0-939914-09-3

Printed in Canada

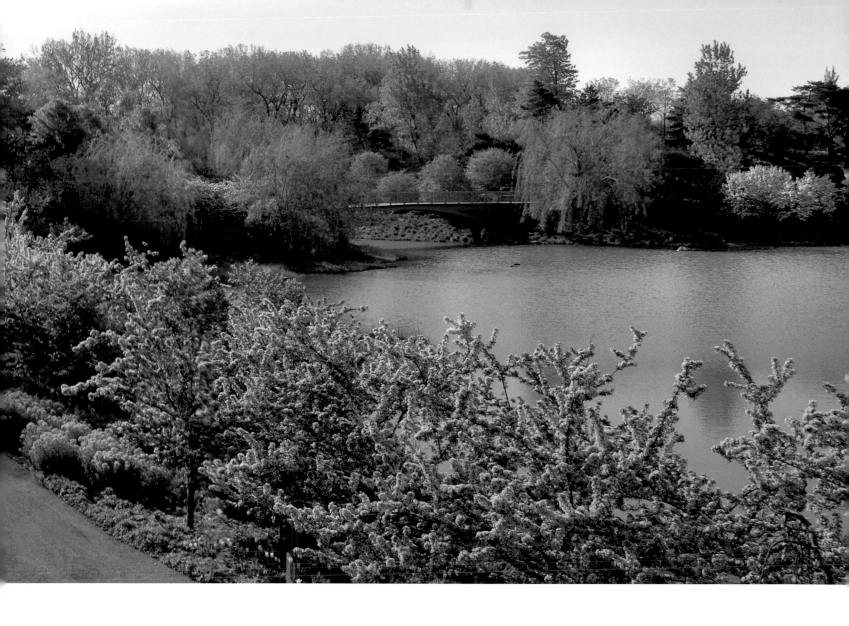

CONTENTS

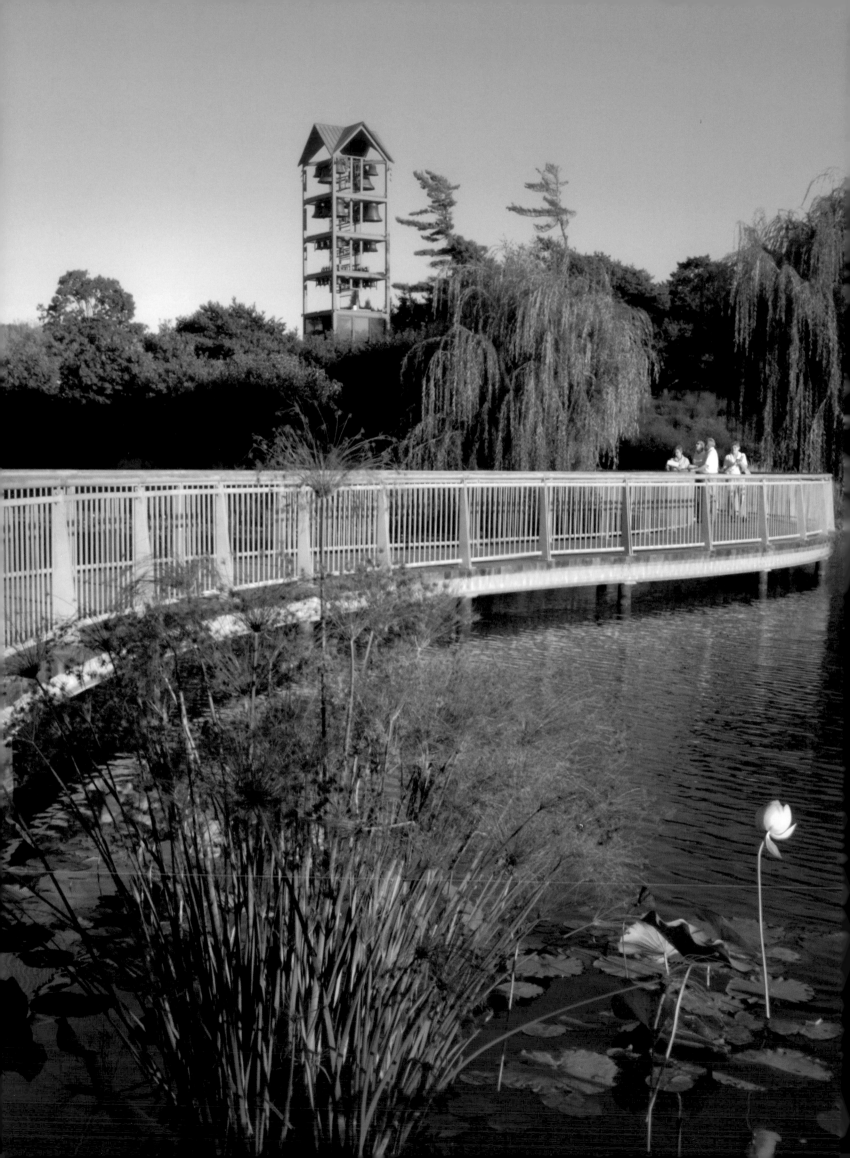

A JOURNEY TO NINE ISLANDS

The mission of the Chicago Botanic Garden is to promote the enjoyment, understanding and conservation of plants and the natural world.

Only four decades ago, the founders of the Chicago Botanic Garden began a remarkable journey. With an unwavering vision of what was possible, a dedicated team transformed 385 acres of degraded land into one of the world's great living museums—a glorious collection of 23 distinctive gardens, created by leading designers, on nine islands and 81 acres of water, surrounded by the natural beauty of an oak woodland, a mile-long river and a 15-acre prairie.

Standing behind the breathtaking vistas and intimate garden rooms is a scientific institution of renown— one of the premier teaching gardens of the world. Each year, the Garden greets nearly 800,000 visitors, including 35,000 students of diverse ages and backgrounds through its education programs that serve broadly. The Garden puts critical knowledge and practical information about plants into the hands of nearly 7,000 scientists, landscape professionals, nature lovers and gardening enthusiasts through courses at the Joseph Regenstein, Jr. School of the Chicago Botanic Garden. It further educates through its research partnerships

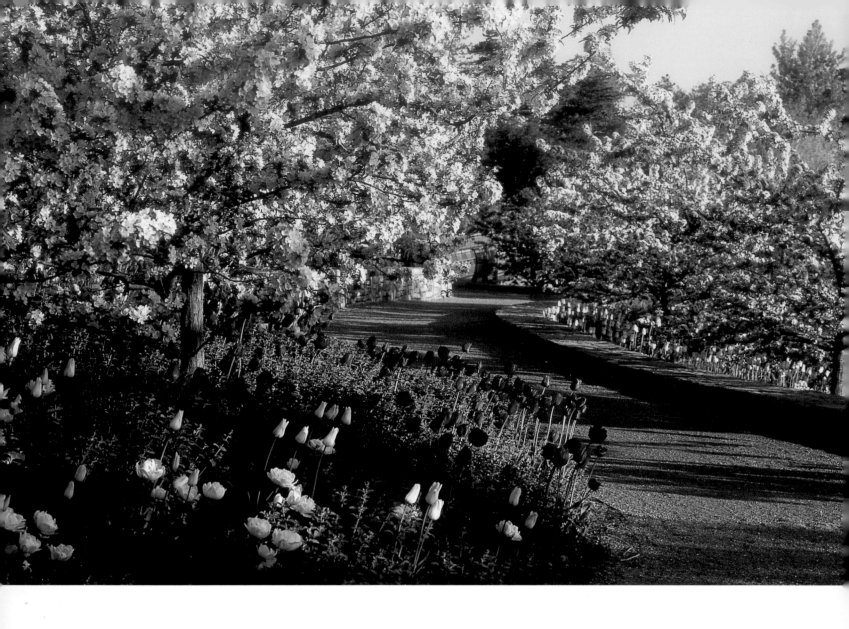

with Northwestern University, Illinois Institute of Technology, the University of Illinois at Urbana-Champaign and the University of Illinois at Chicago. Internationally, the Garden shares its expertise in seed banking, rare plant monitoring, plant collecting and invasive plant management—knowledge gained through systematic and molecular research, foreign plant collection and study, as well as through the hands-on restoration of the Garden's own natural areas.

The creation of this grand, important garden began with a dream, which shaped a master plan by John O. Simonds and Geoffrey Rausch, inspired by an old and famous water garden that once flourished near Beijing, China. It was a retreat for Chinese emperors, built in the early 18th century on a series of islands,

whose shores were planted with lotus flowers. It was called "The Garden of Perfect Brightness." The image of a lotus rising from the depths is a perfect metaphor for the Chicago Botanic Garden's growth—lagoons becoming lakes, clay soil forming islands to nourish over 2.3 million plants and support landmark buildings. Unlike the great Chinese garden, which was closed to everyone except the elite, the Chicago Botanic Garden created paths to even the most remote Garden areas to welcome all visitors to take journeys of their own—over 15 million since opening to the public in 1972.

Come experience your own journey in the pages of this book and on the paths of every island—and in every garden—of the Chicago Botanic Garden.

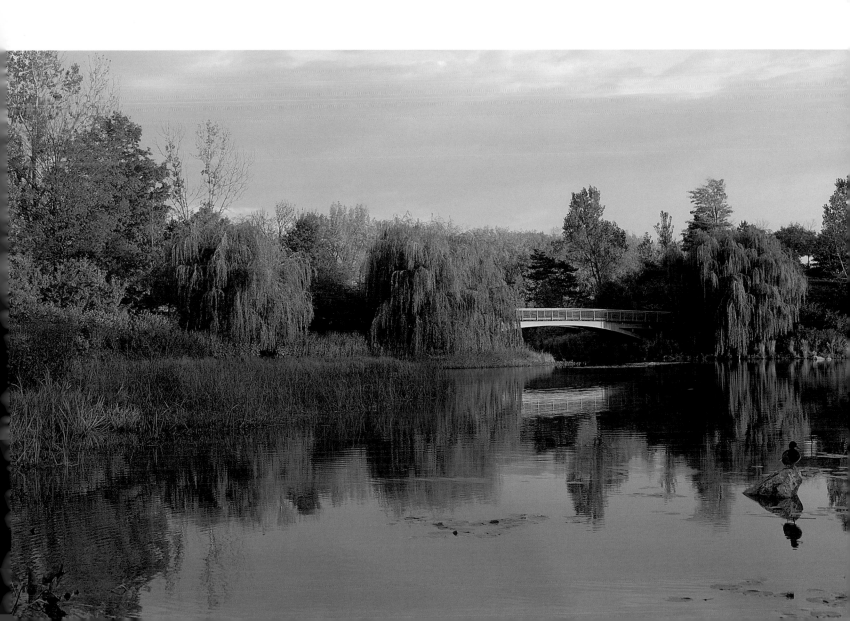

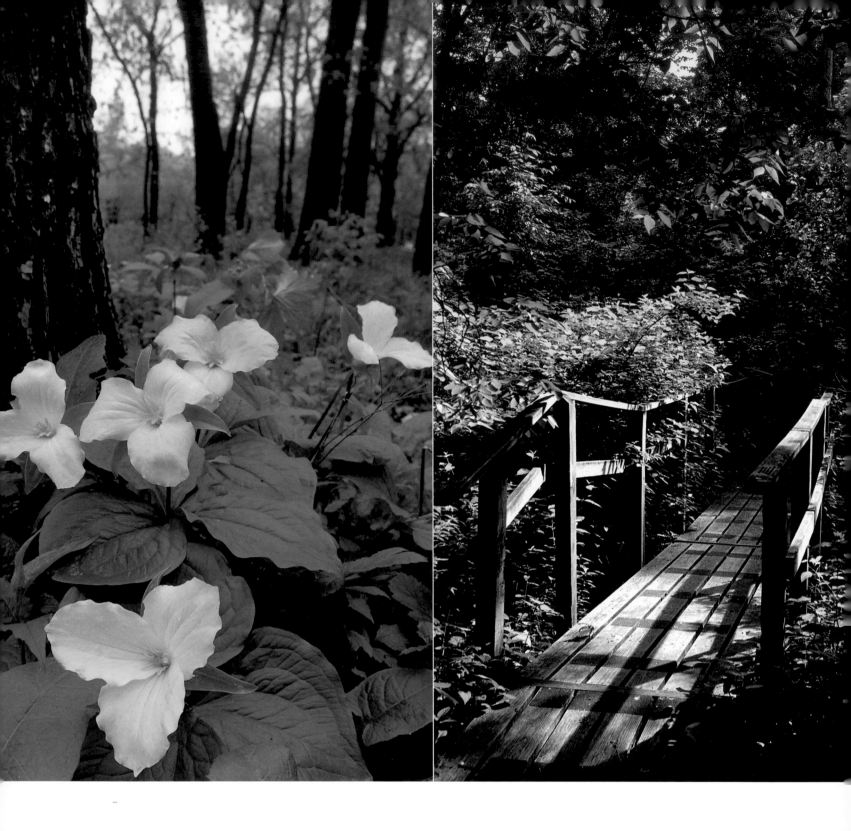

MCDONALD WOODS A walk in McDonald Woods is a journey through time. In these 100 acres of oak woodland, the Garden is restoring a piece of Illinois natural history. From the tallest oak tree to the most ephemeral wildflower, the Garden is reclaiming layers of native plant communities, wildlife habitats and diverse ecosystems, which once existed in this region.

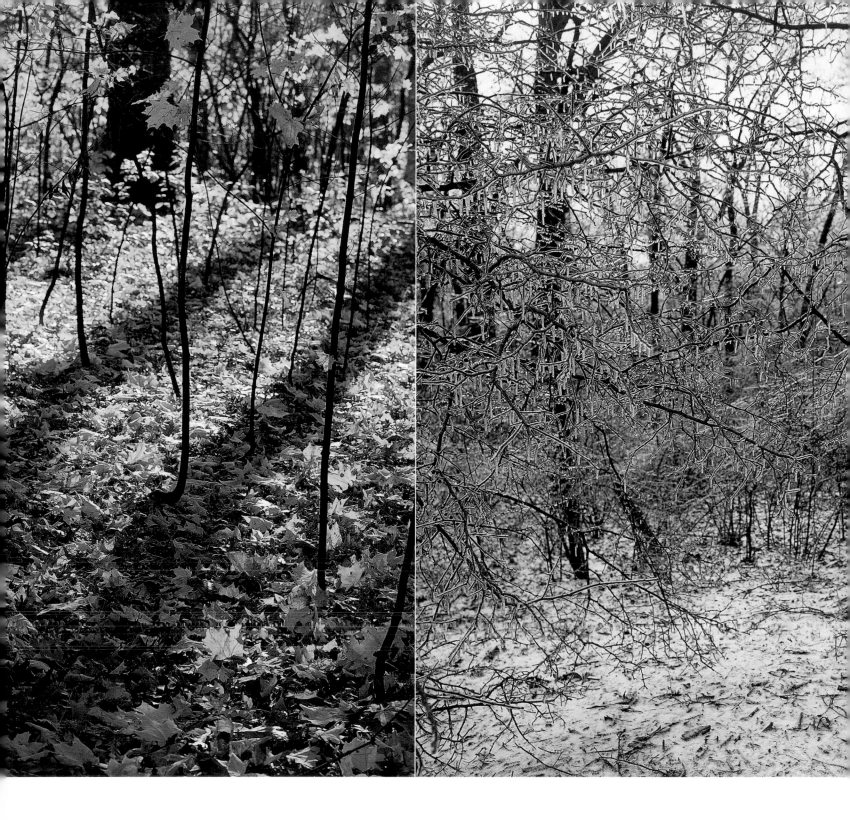

Today, as hawks and owls nest and the number of wildflowers increases annually, Garden staff and volunteers monitor for rare plants, engage in a heroic effort to remove invasive species, study new techniques in conservation management, and continue the restoration process, so vital to the Garden's mission, to bring beauty and biodiversity to the Woods and to share these treasures with visitors.

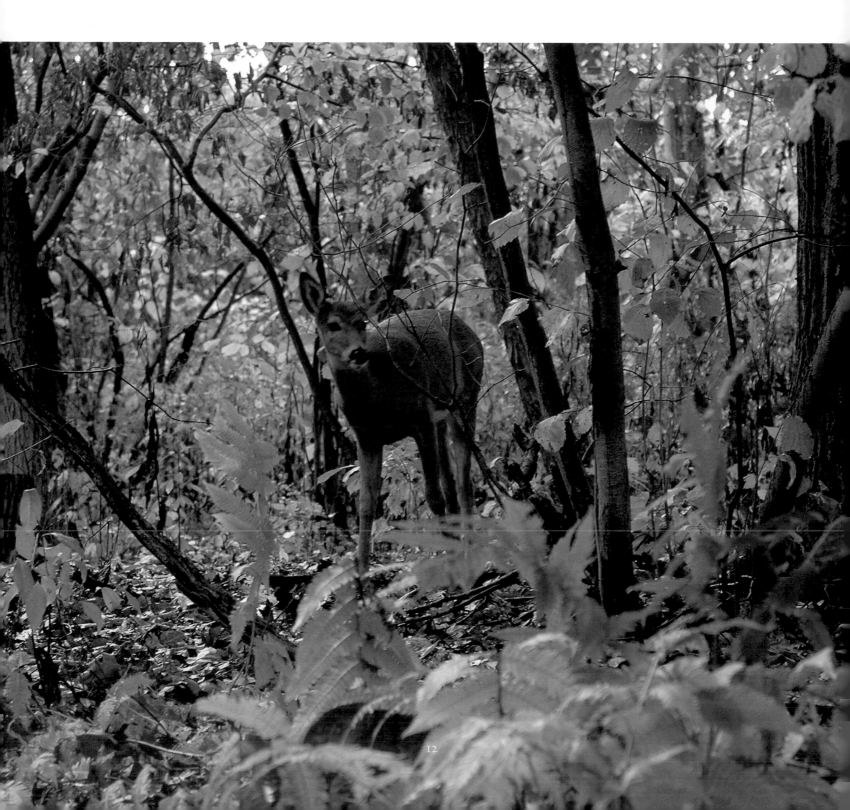

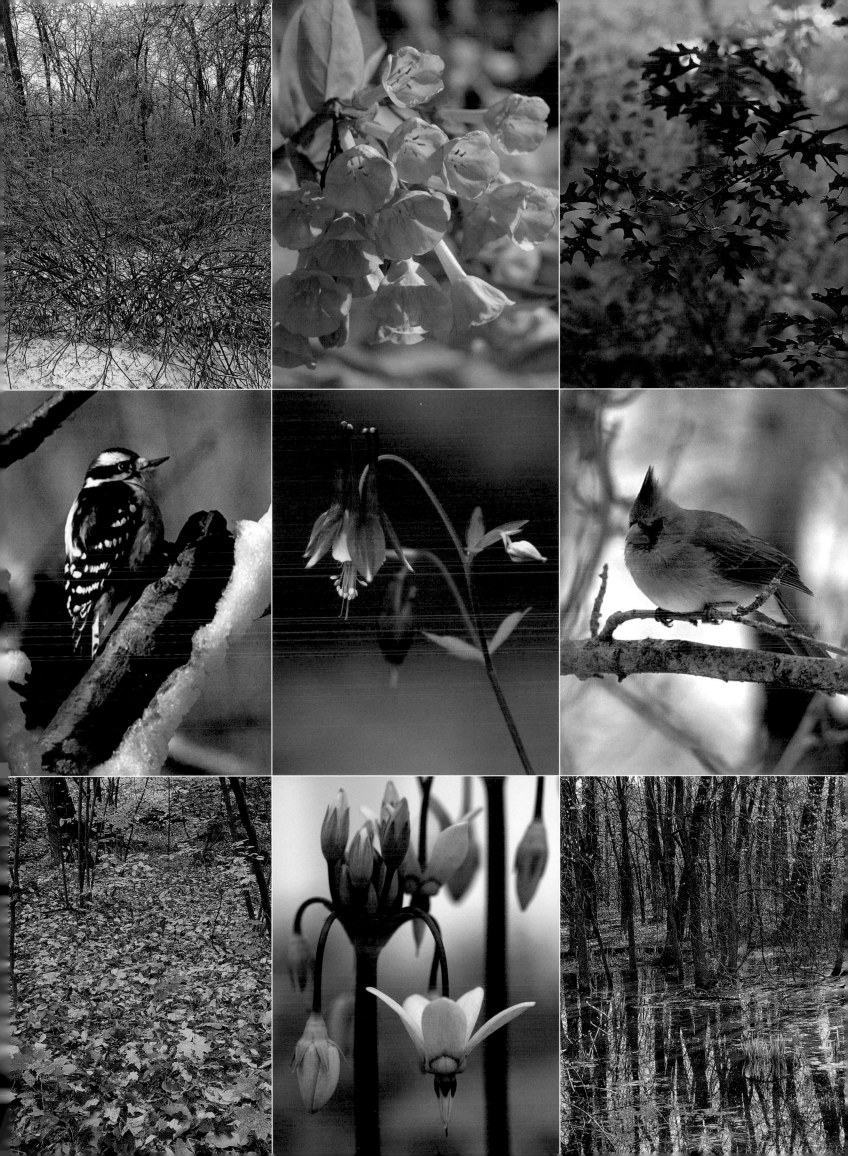

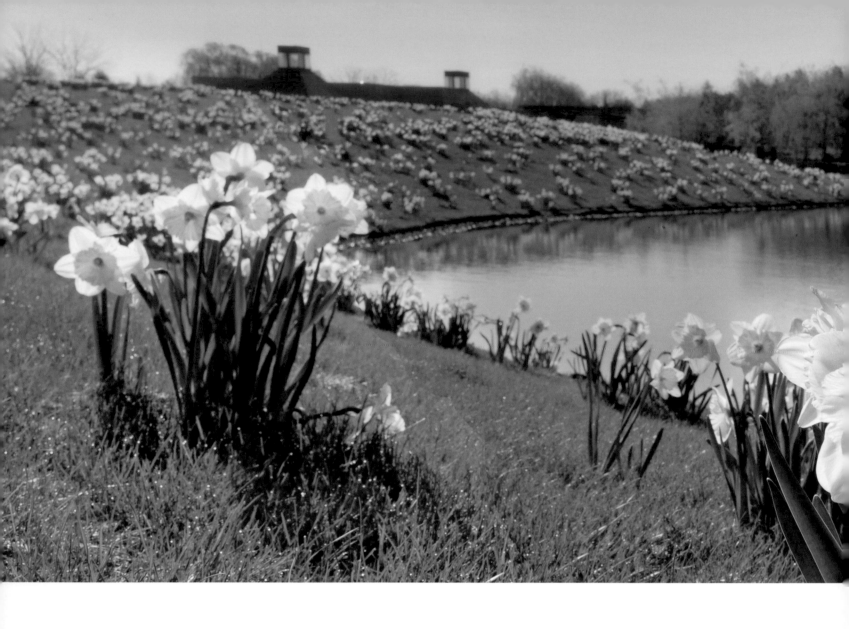

BIRD ISLAND A small island studded with young oaks is the northernmost of the nine islands. In April, it is transformed into a frothy meadow of thousands of yellow and white *Narcissus* trumpeting the official arrival of spring.

Herons, egrets, ducks, sandpipers, swans and other waterfowl along the shoreline are among the 255 different species of birds that alight at the Garden. Some migrating birds rest and feed here for just a week or two, while others stay and raise their young.

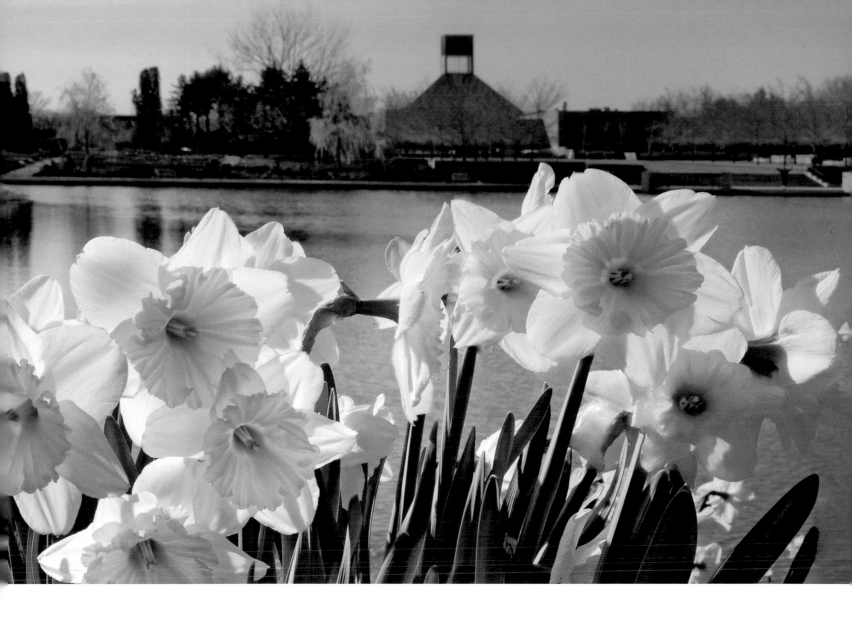

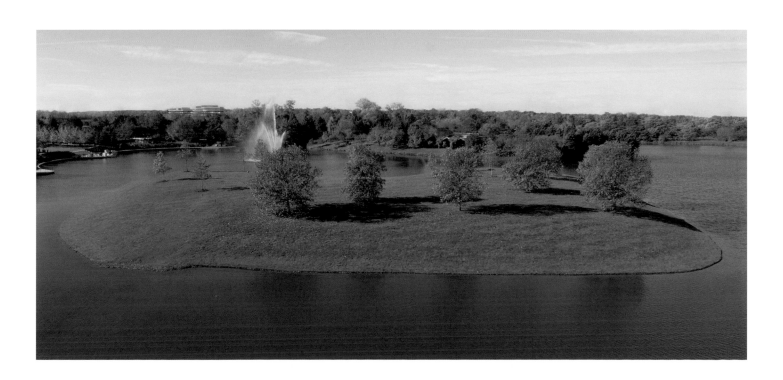

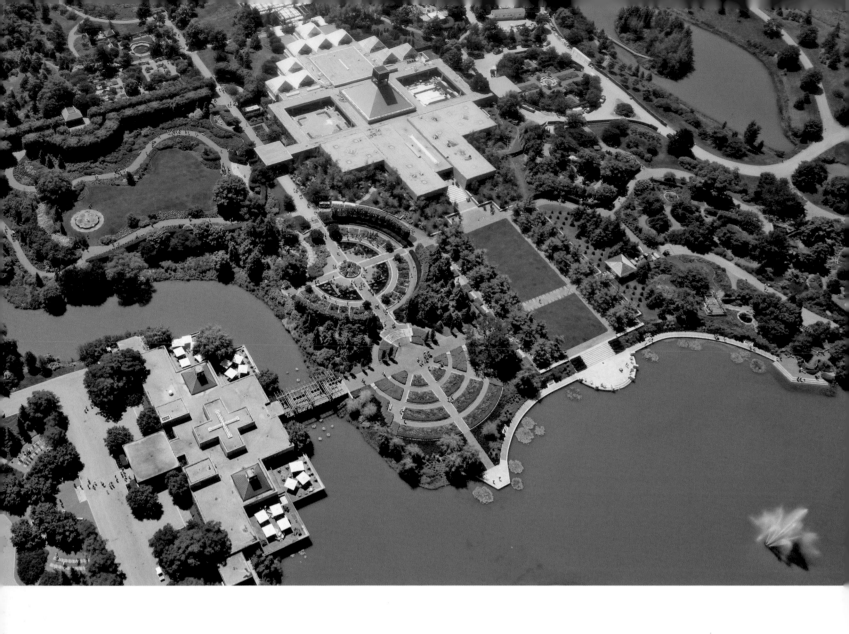

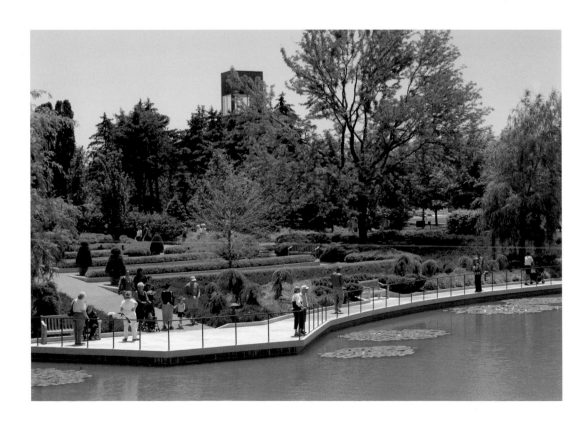

MAIN ISLAND Greene Bridge welcomes visitors to the heart of the Garden—Main Island—home to Joseph Regenstein, Jr. School, Lenhardt Library, Regenstein Center and more than half the 23 display gardens. From this central point, all views lead to lakes and connecting bridges, surrounding islands and the magnificent gardens that await.

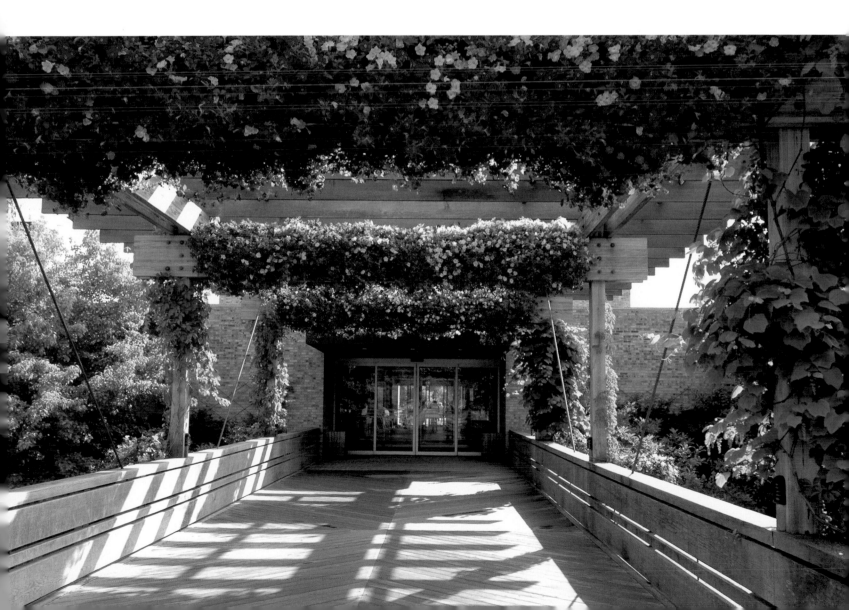

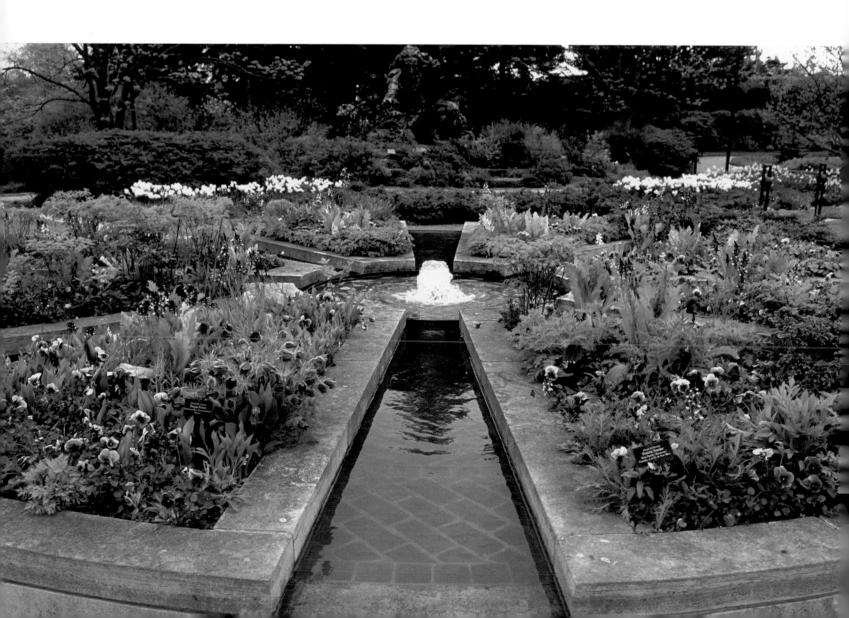

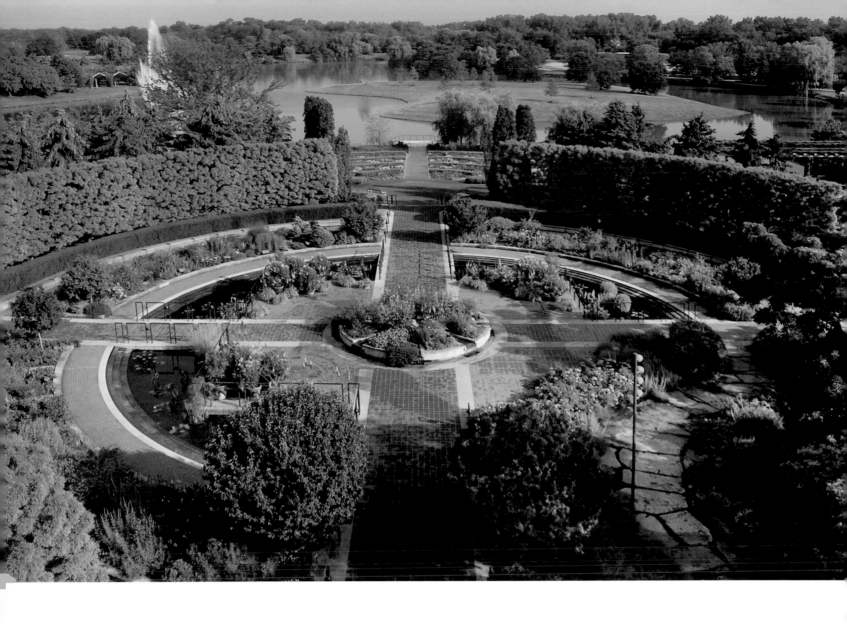

HERITAGE GARDEN

HERITAGE GARDEN Heritage Garden, modeled after one of Europe's oldest botanic gardens established in Padua, Italy, in 1545, pays tribute to the history and science of collecting, naming and displaying plants. Like its predecessor in Padua, Heritage Garden—designed by the firm Environmental Planning and Design—follows the example of the medieval *Horti Conclusi*—or enclosed gardens.

Within this circular garden, which is divided into four quadrants by two walkways, curving raised beds of plants are organized by region of the world or by plant family. The beds alternate with gently terraced waterfalls and pools, in which tropical water lilies bloom into October (thanks to their basins of heated water). A large bronze statue of Carolus Linnaeus, sculpted by Robert Berks in 1982, presides. Linnaeus, the 18th-century Swedish botanist who perfected binomial nomenclature—a system used worldwide to organize and name all living organisms—was personally responsible for naming more than 30,000 plants. Botanic gardens today are the guardians of this tradition as they continue to display, conserve, record and share scientific data with fellow institutions and the public.

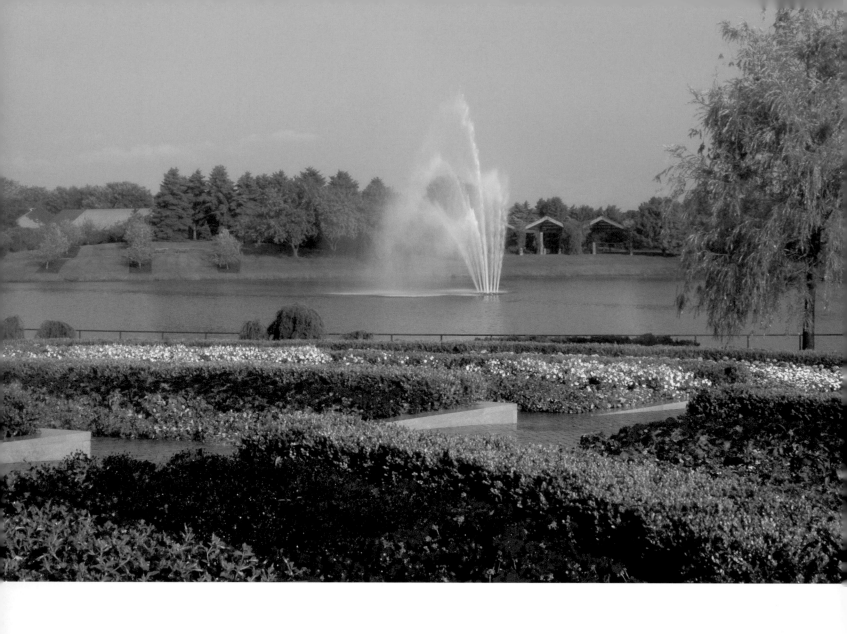

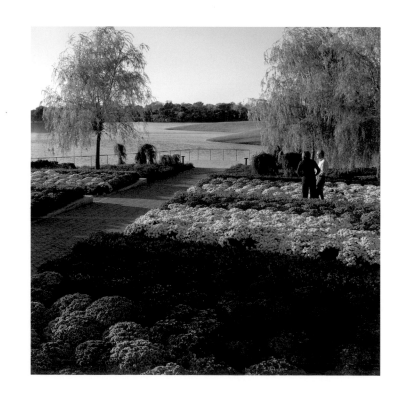

THE CRESCENT Through its collaborations with noted landscape architects and designers, the Chicago Botanic Garden remains in the forefront of garden design, creating bold and striking gardens in its public spaces, which complement the views of the surrounding landscape.

The Crescent, designed by renowned landscape architects Dan Kiley and Peter Morrow Meyer, celebrates the changing seasons with masses of exuberant, high-impact flowering plants. Terraced steps lead down to the water's edge, where water lilies bloom, Smith Fountain explodes with mist (and often a rainbow) and a lakefront walkway invites a stroll.

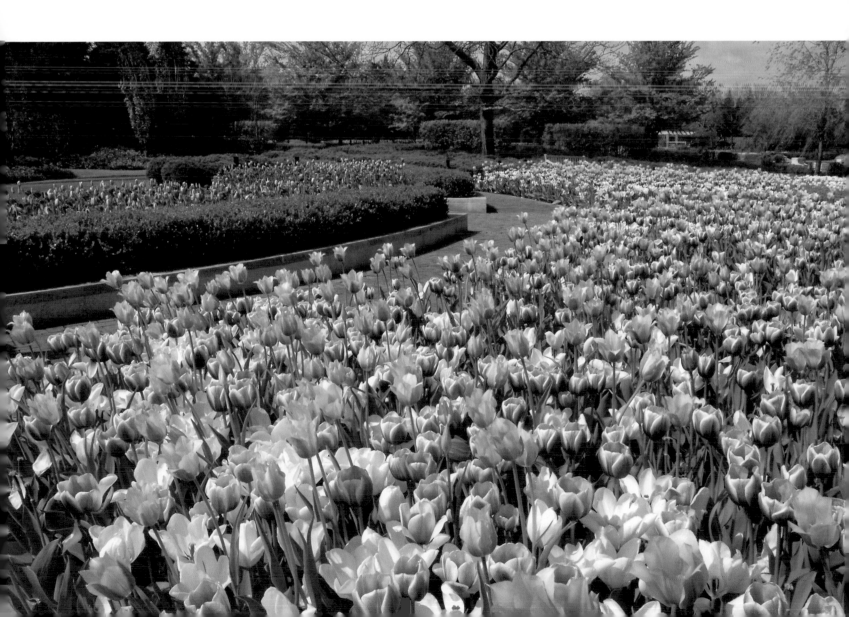

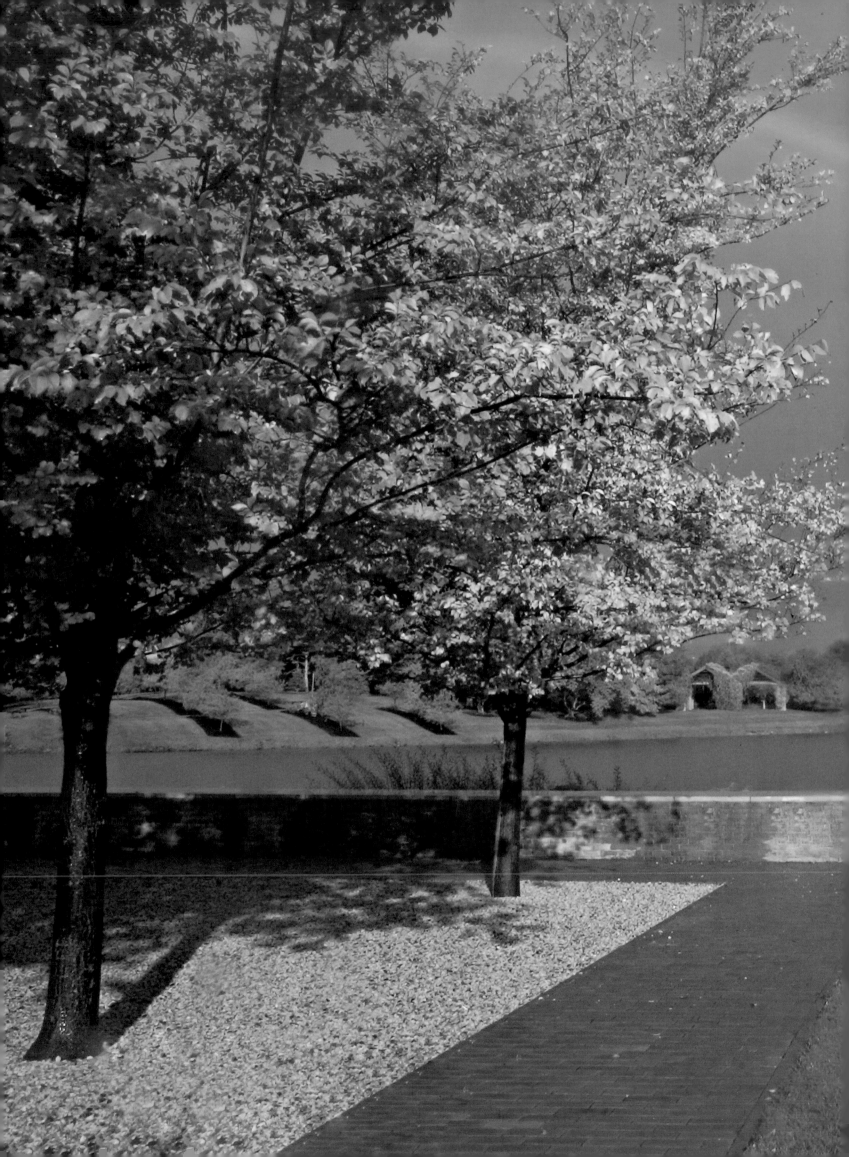

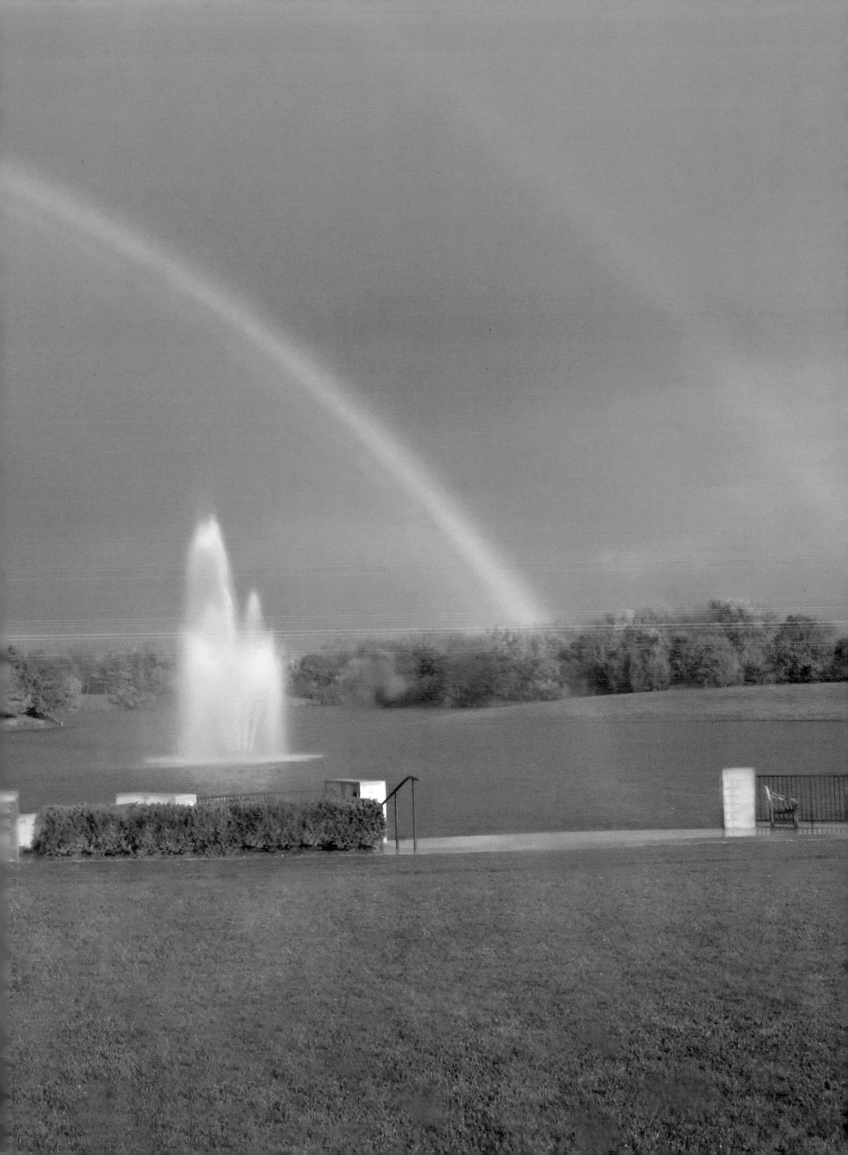

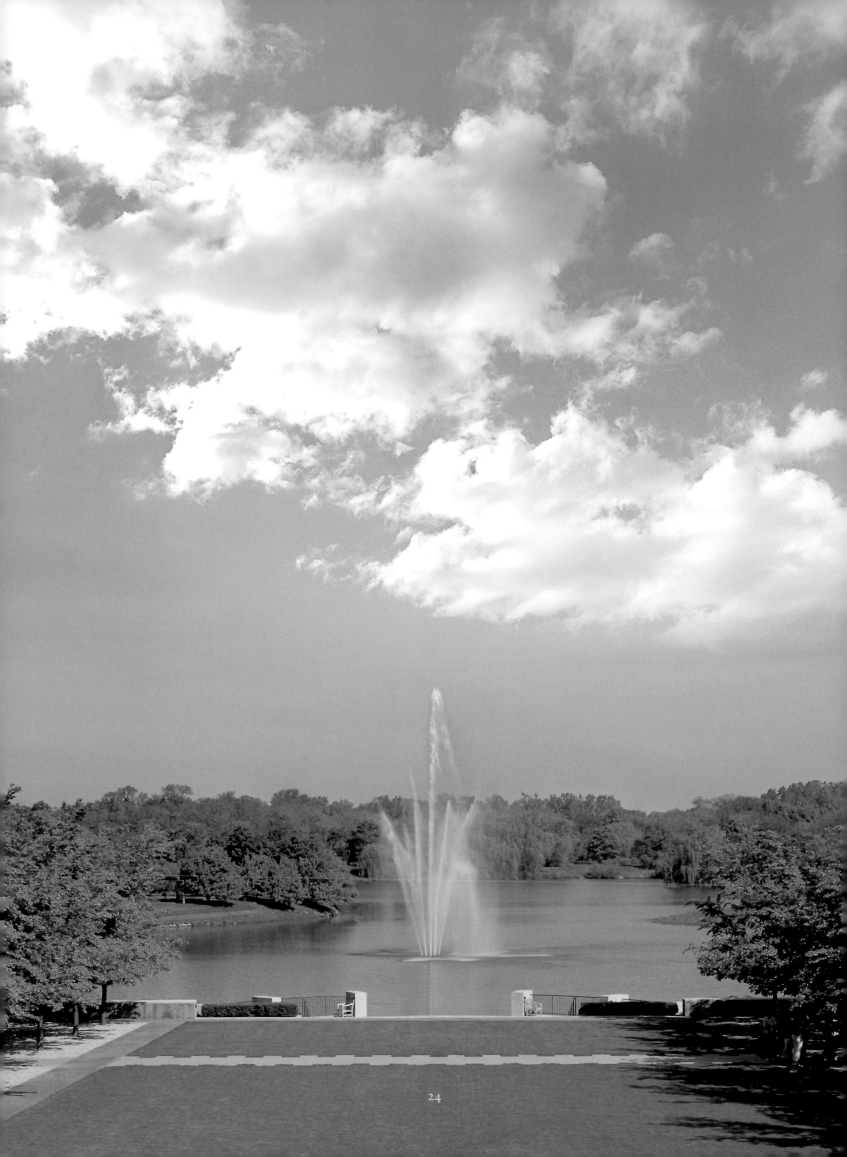

THE ESPLANADE A further collaboration of landscape architects Dan Kiley and Peter Morrow Meyer, the Esplanade is the formal welcoming plaza to the Garden's Regenstein Center. Grand, open walking spaces, cooling water features and panoramic vistas create an inviting public gathering place.

Recalling the European tradition of a central square, the Esplanade includes a focal statue, *The Sower* (see following page), topiary plants, three long fountain pools and *allées* of disease-resistant Commendation™ elms, developed by the Morton Arboretum, one of the Garden's partners in the Chicagoland Grows® plant introduction program, which introduces superior plants to Midwestern gardens.

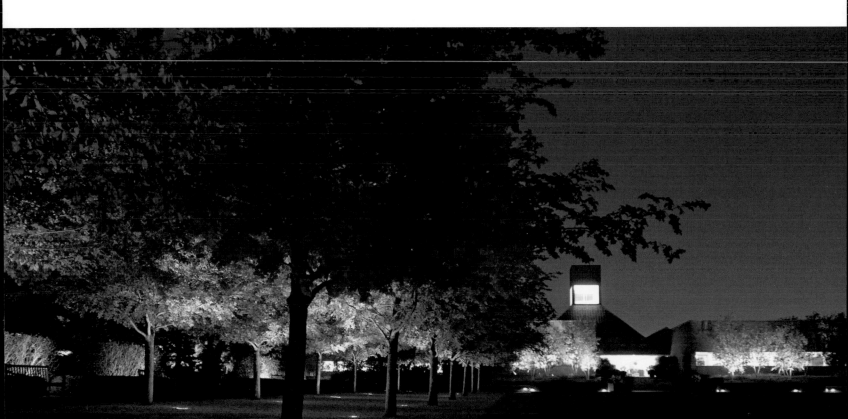

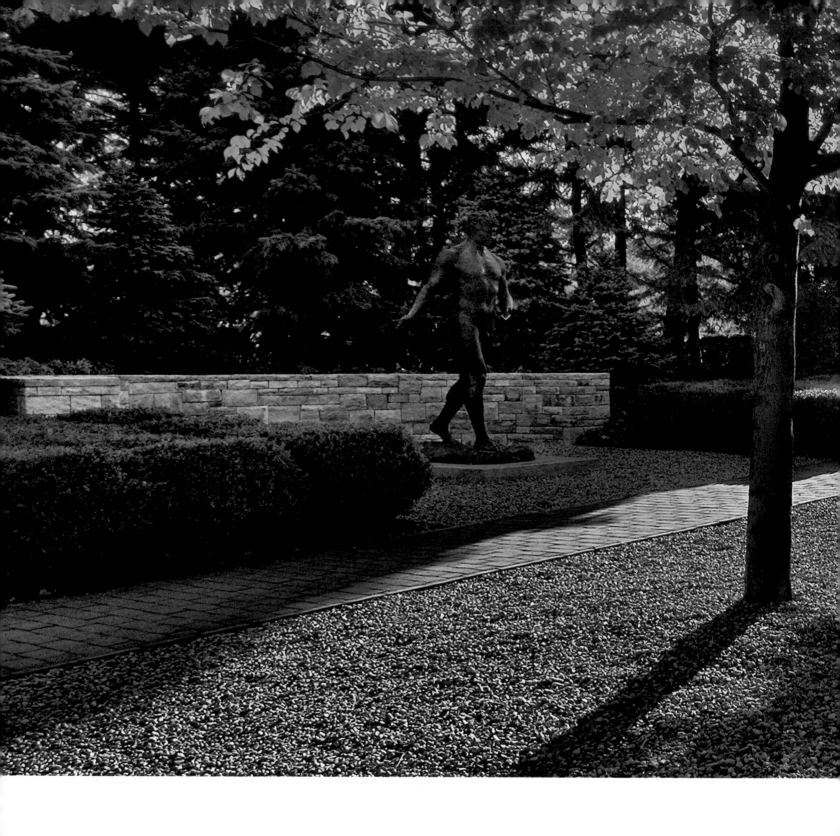
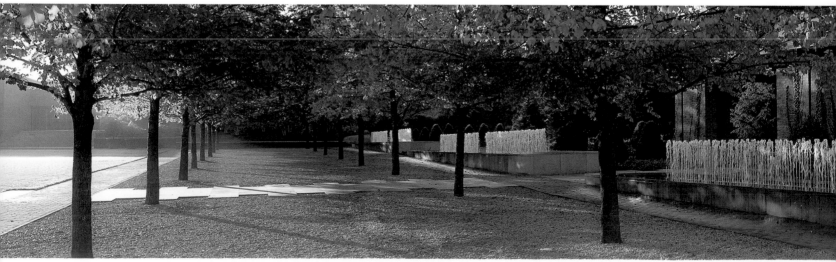

THE SOWER A recent addition to the Garden's outdoor sculpture collection is *The Sower*, a gift from The Art Institute of Chicago. At seven feet tall, the classic male figure, cast in bronze, was created by Albin Polasek (1879–1965), a Czech-American sculptor, and was first unveiled on the steps of the Art Institute in 1916 to great controversy. *The Sower* celebrates the Garden's dedication to spreading the seeds of learning about plants and the natural world, and symbolizes the "seeds" for the Chicago Botanic Garden that were sown at the Art Institute, which housed the Chicago Horticultural Society for many decades after its founding in 1890.

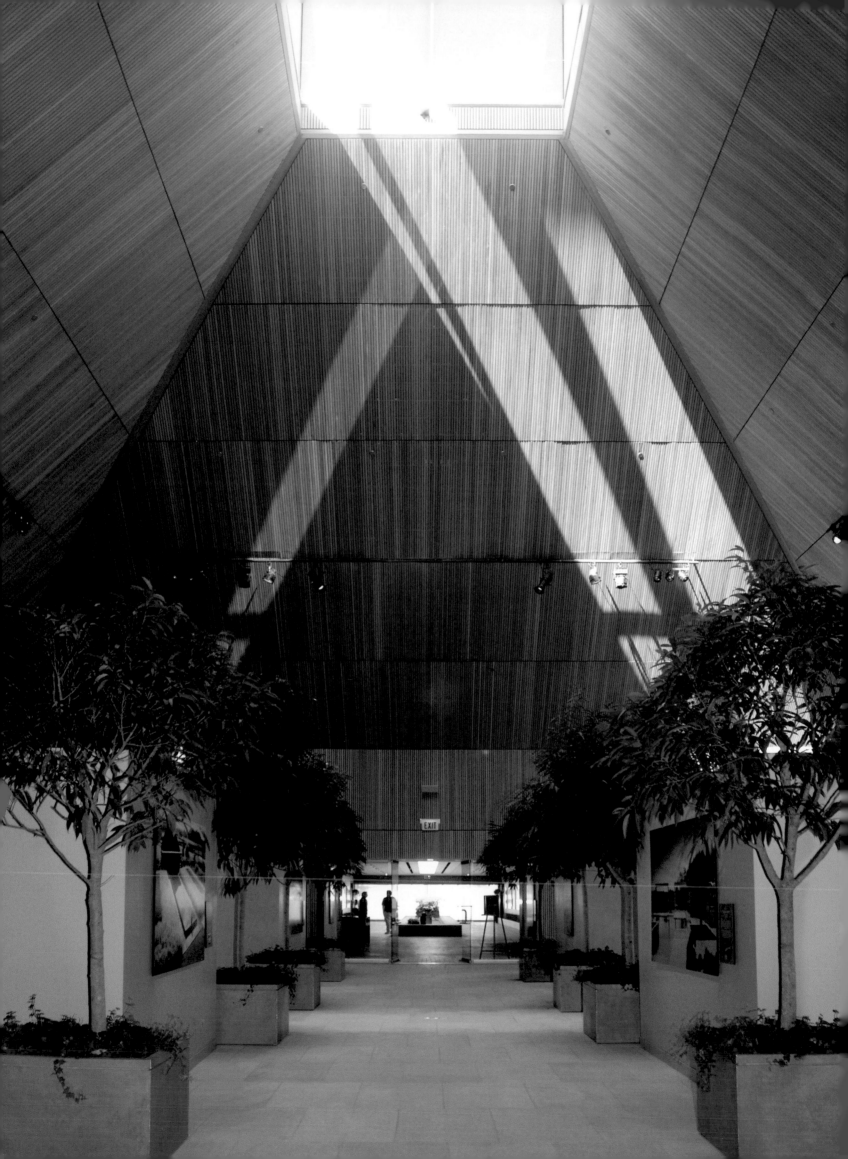

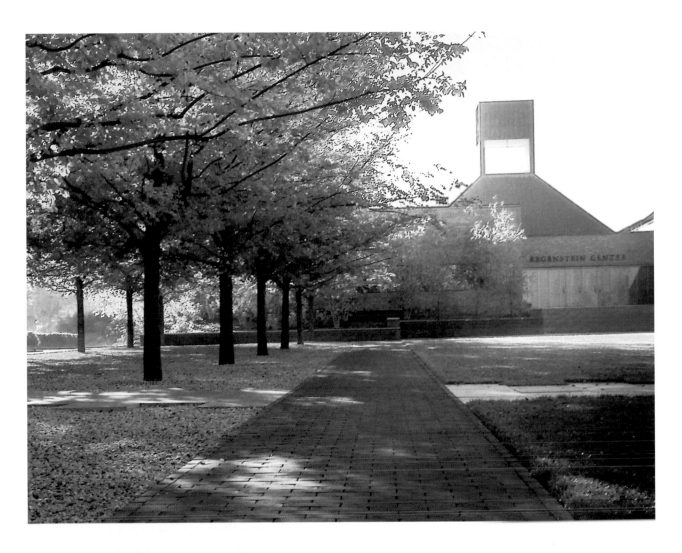

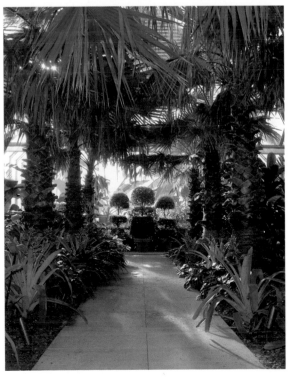

REGENSTEIN CENTER Designed in 1975 by distinguished architect Edward Larrabee Barnes and renovated in 2006 by award-winning architect Larry Booth, Regenstein Center, with its public galleries, bonsai courtyards, greenhouses, 25,000-volume Lenhardt Library and rare book collection, and Joseph Regenstein, Jr. School, is a testament to the Garden's commitment to excellence.

As living classrooms and warm retreats during winter months, the three greenhouses display plants from ecosystems around the world, including tropical, semitropical and arid zones. From its palm *allée* to the remarkable view of Smith Fountain, Regenstein Center provides a perfect backdrop for the Chicago Botanic Garden's collections—both inside and out.

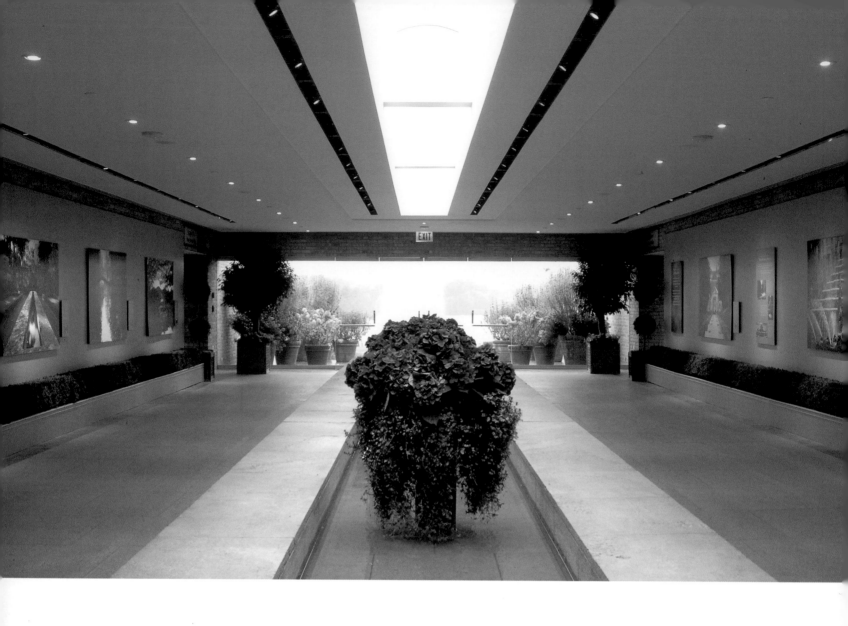

Adjoining Regenstein Center's sleek Krehbiel Gallery and its main room—great Nichols Hall, whose walls and ceiling are clad in elegant Oregon hemlock ventwood—are two exquisite garden spaces, Frances C. Searle Courtyard and Mary Withers Runnells Courtyard. Peter Morrow Meyer designed the courtyards to present the Garden's preeminent bonsai collection, which was established in 1978 and enhanced in 2000 by a gift of 19 exquisite specimens from Japanese bonsai master Susumu Nakamura. These living works of art, perfectly positioned on granite benches, feature examples of fragrant jasmine, bougainvillea, beech and many varieties of pine. Up to 60 trees from the Garden's collection can be viewed at once—remarkable by day, breathtaking at night—from May to November.

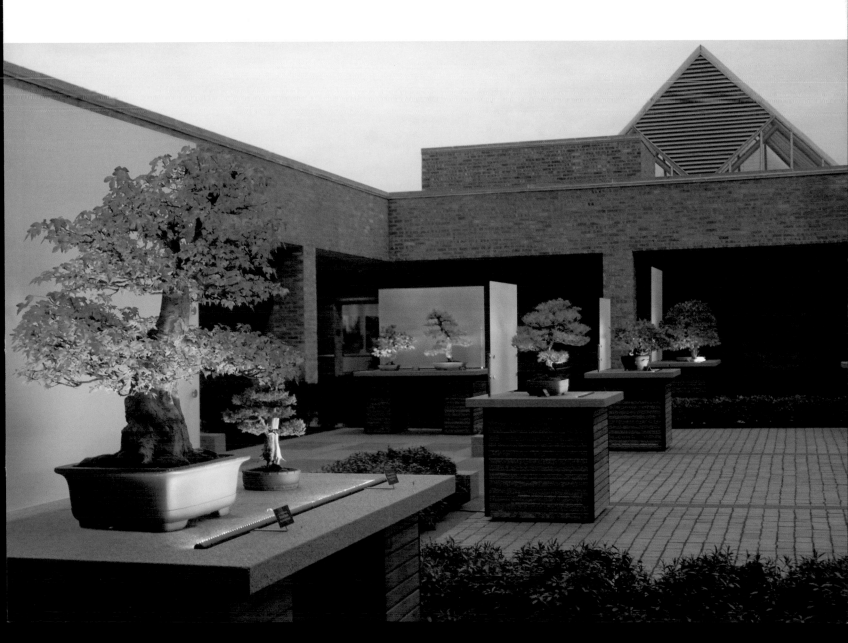

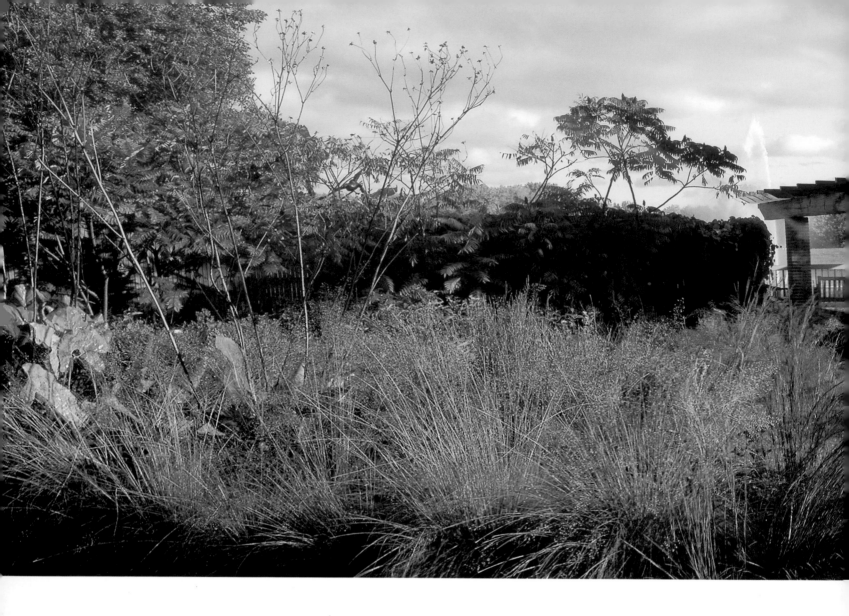

NATIVE PLANT GARDEN The all-season beauty of native Illinois flora is on display in this half-acre garden where visitors learn how to integrate native plants into their own landscapes. Two distinct environments—sunny prairie and shaded woodland—are landscaped with communities of plants ideal for those settings.

Swaths of green lawn pathways curl through the prairie garden, contrasting with the naturalistic abundance of flowering plants and native grasses. Benches and a deck offer opportunities for bird and butterfly sightings.

This learning garden is designated an official native plant demonstration site by Chicago Wilderness, an alliance of nearly 200 public and private organizations formed to protect the native flora and fauna of the Chicago region.

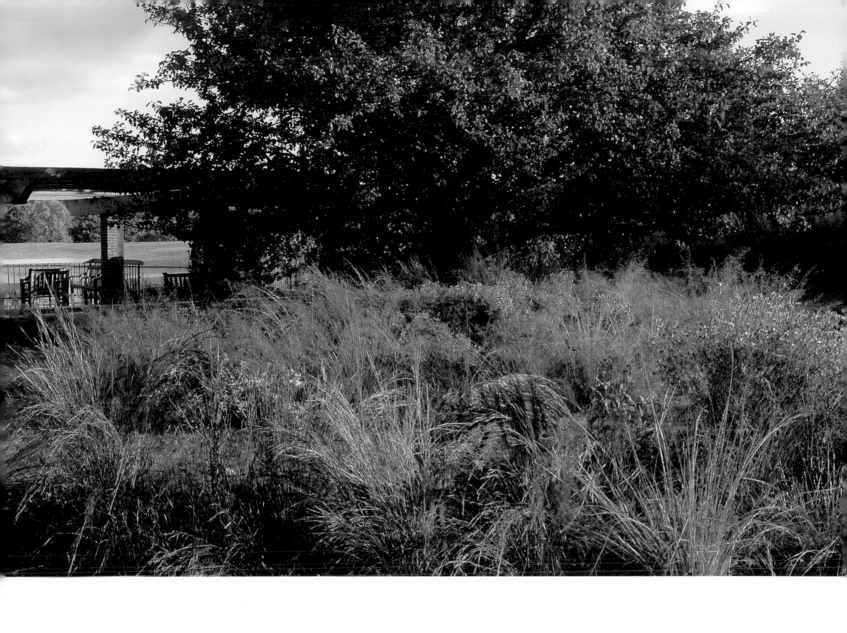

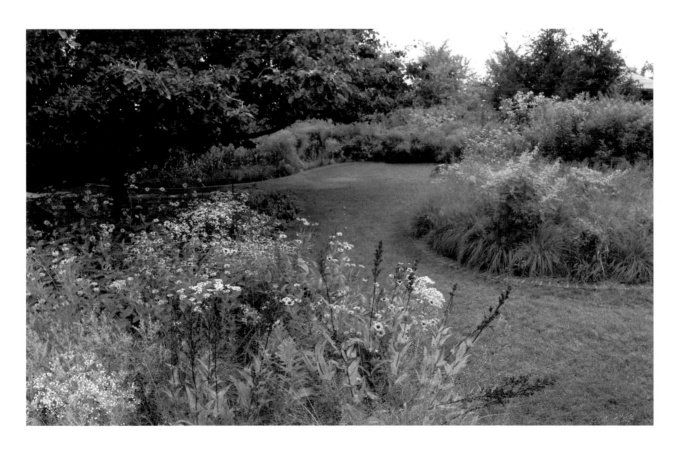

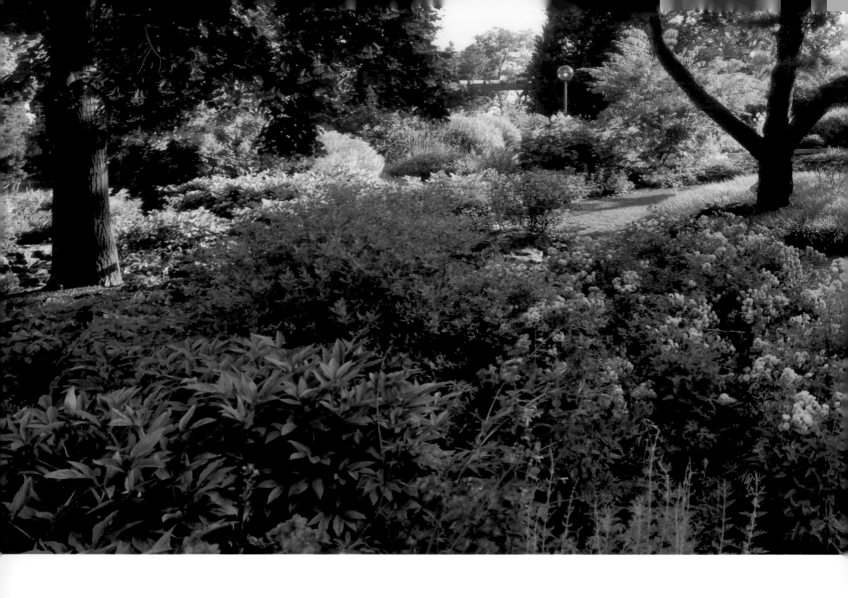

FARWELL LANDSCAPE GARDEN Both home and professional gardeners look to the Chicago Botanic Garden for inspiration and ideas. How do Garden horticulturists solve the same design challenges Midwestern gardeners face in their landscapes, and what plant groupings achieve maximum effect? This series of pleasing vignettes, designed in part by the firm Environmental Planning and Design, Janet Meakin Poor and Craig Bergmann, presents solutions.

An intimate courtyard garden features espaliers, statuary and a formal knot garden composed of tightly pruned geometric designs of low-growing wall germander and lavender. In contrast, the medicinal and culinary herb garden spills forth, requiring decorative wattle fencing of interwoven twigs and branches to restrain its abundance. A fragrant herb garden of mounded scented geraniums, rosemary and lavender surrounds Sylvia Shaw Judson's *Naughty Faun*, 1921 (above). Other garden scenes in the Landscape Garden include an ericaceous bed of rhododendrons and azaleas, a series of perennial beds and a rock garden—all designed on a scale the homeowner can appreciate. The four perennial beds contain easy-to-grow, cool-color, streamside and traditional perennials, showy May through autumn, while the rock garden features dwarf and alpine plants and is especially beautiful in early spring.

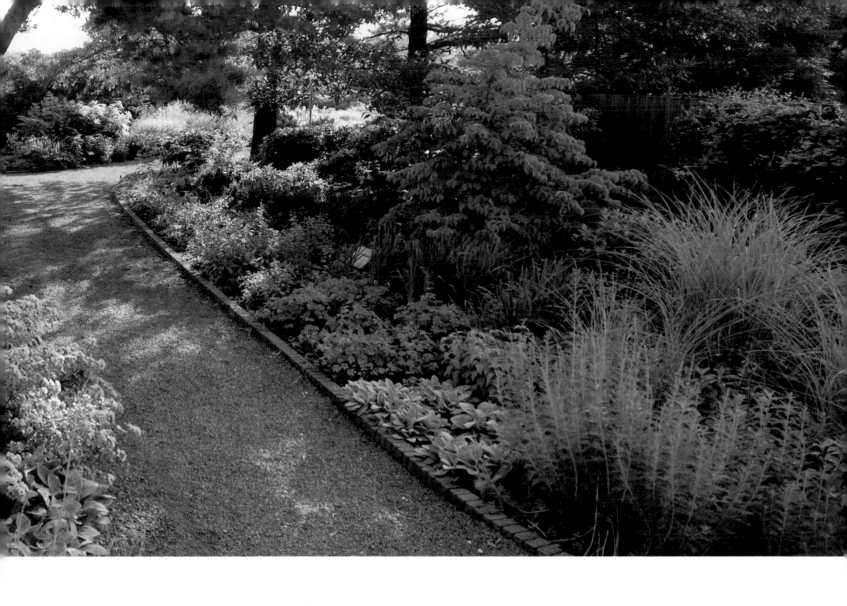

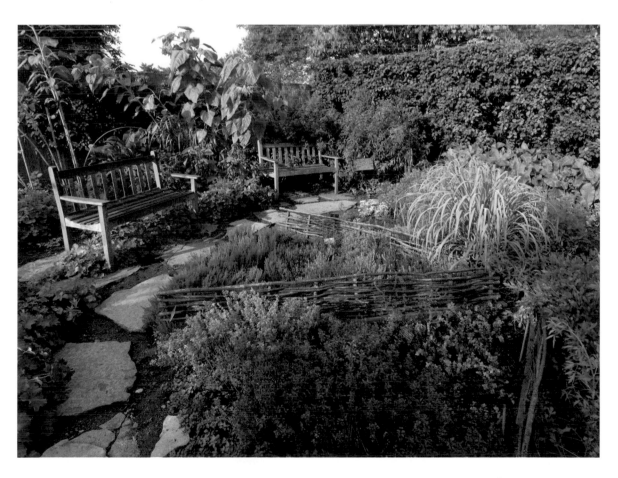

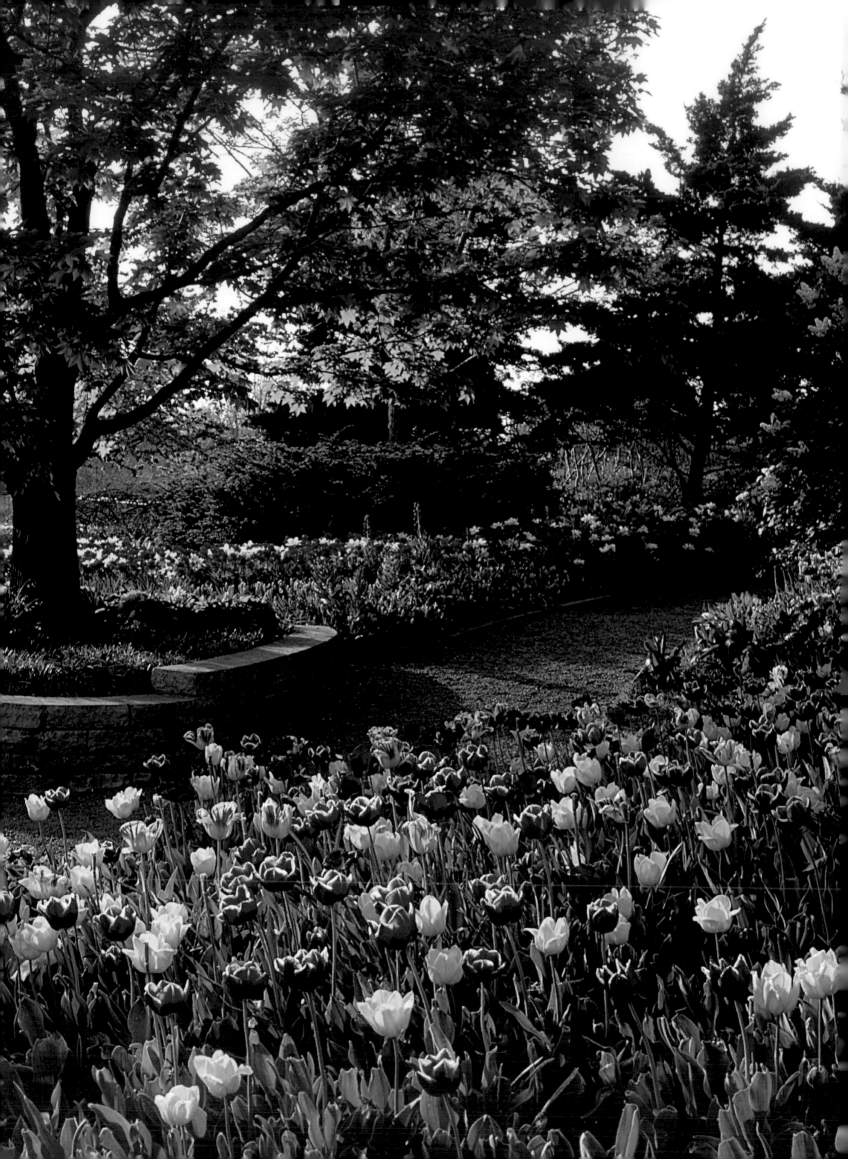

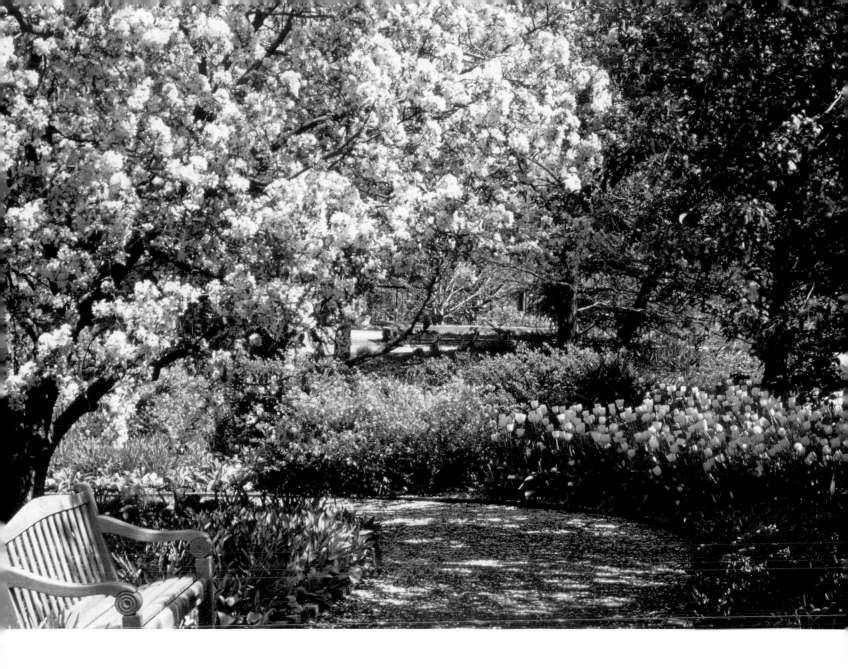

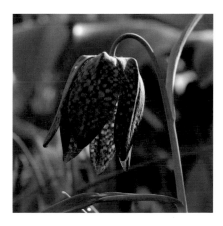

GRAHAM BULB GARDEN Tens of thousands of perennial and annual bulbs are the stars of this rolling, water's-edge garden, renovated by landscape architect Douglas Hoerr, which features the new and unusual in the world of bulbs. These flowering jewels bring magic to mixed borders and bridge the seasons with saturated color, remarkable form and intoxicating fragrance.

Rivers of brilliant tulips and daffodils flow through the landscape, while fritillaries, allium and lilies punctuate the garden with their statuesque forms. Masses of old-fashioned favorites change annually to complement the growing collection of connoisseur specialty bulbs. Nonhardy bulbs and tuberous dahlias function as summer annuals.

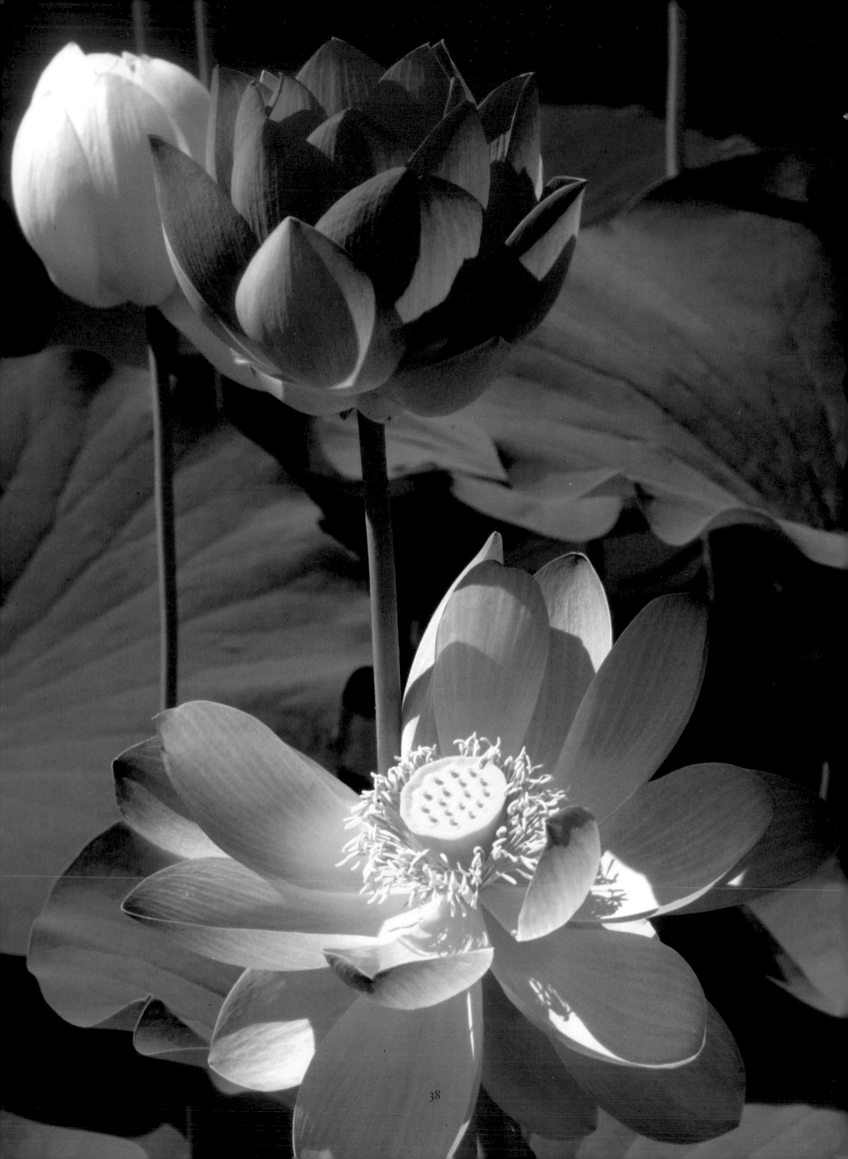

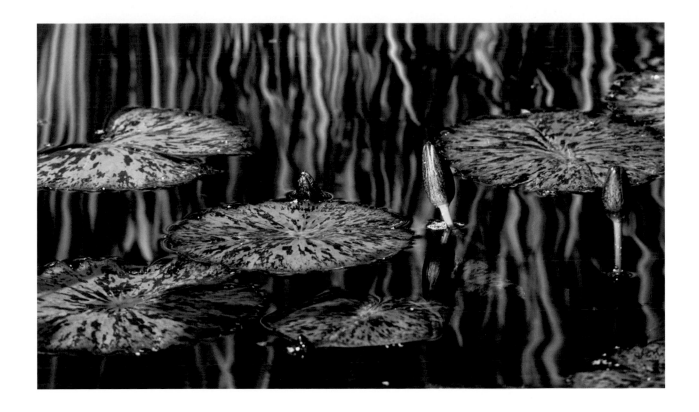

AQUATIC GARDEN Boardwalks skim over the water's surface, allowing visitors as close a view as possible of the magnificent water lilies and lotuses of this garden. The exquisite shapes and luminous colors of these aquatic masterpieces have inspired artists, as well as gardeners around the world—from the early landscape designers of China, Egypt and Persia to contemporary aquatic container gardeners. The ancient sacred lotus represents purity, beauty and fertility and was symbolic in the birth of both Hinduism and Buddhism. Today, it remains an emblem of truth and beauty throughout many cultures—and the symbol of the Chicago Botanic Garden.

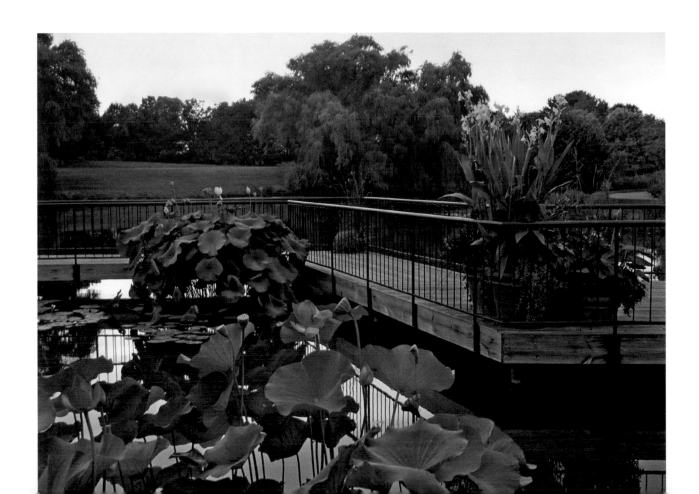

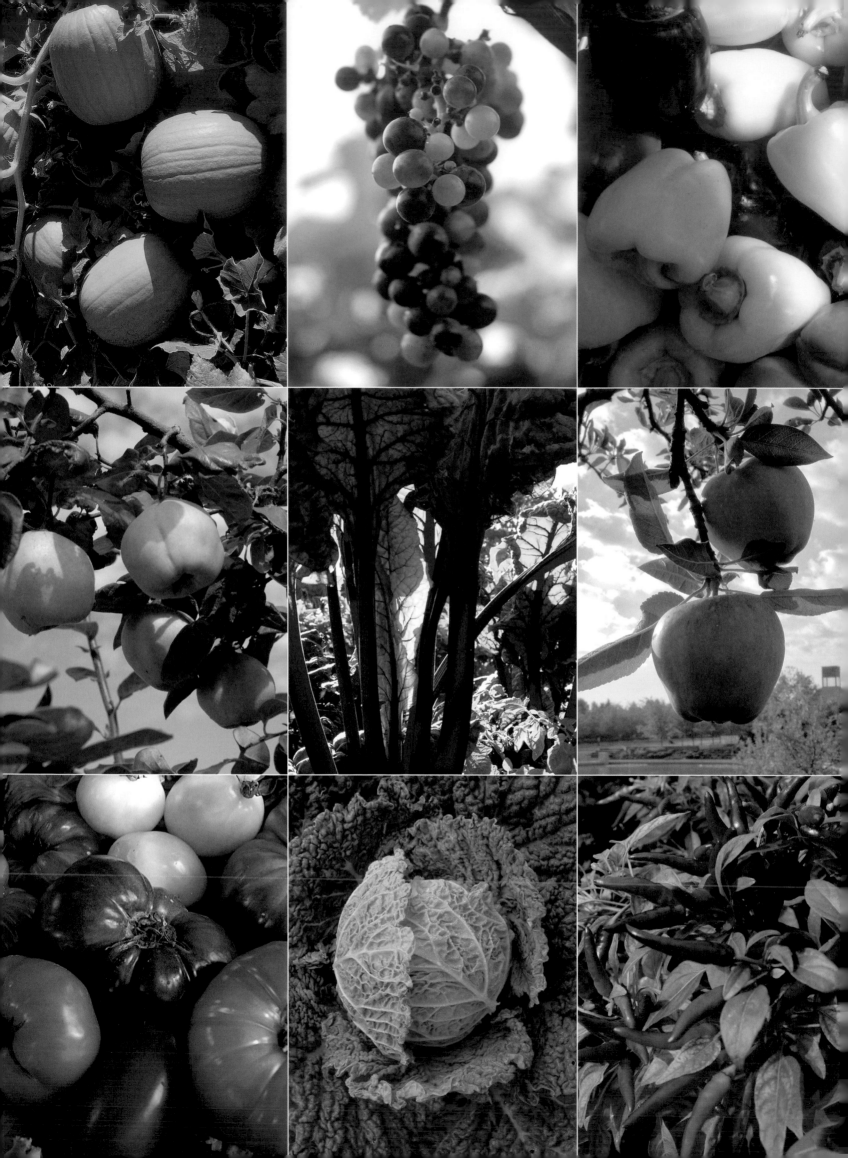

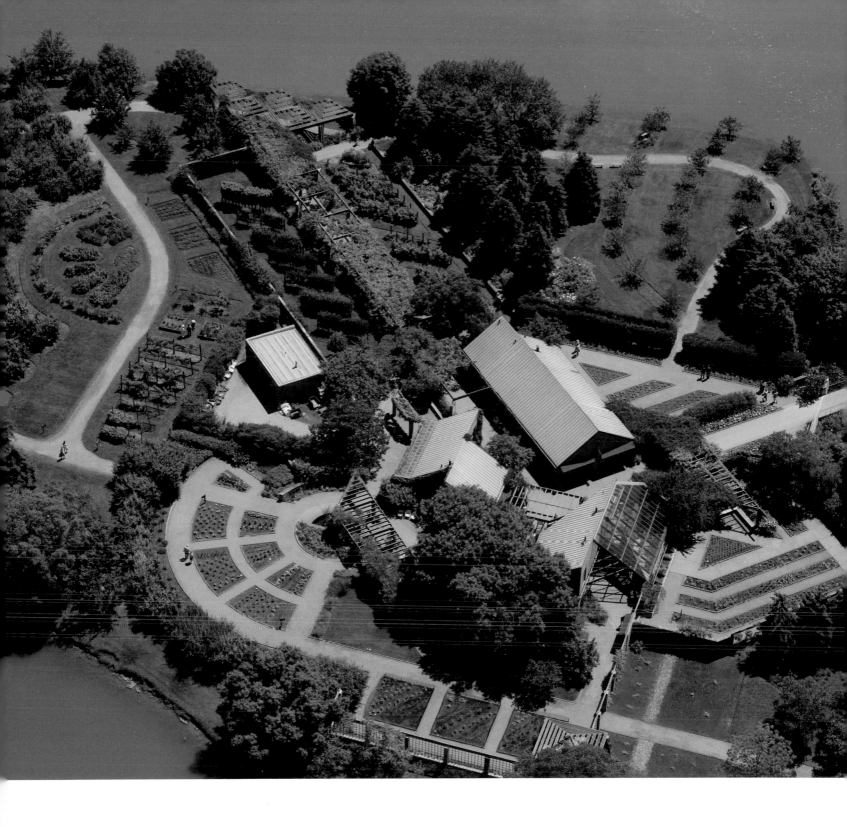

REGENSTEIN FRUIT & VEGETABLE GARDEN "Joyful abundance" describes this garden. Growing healthy plants that produce eye-catching, delicious food crosses all boundaries, embraces all nationalities and age groups, and speaks directly to our Midwestern heritage. Five hundred varieties of food crops are grown on four acres—from berries to nuts, herbs to apples and vegetables to grains. Lettuces cascade from hanging baskets; grapevines become part of the architecture; and gorgeous intensive garden display beds are composed entirely of edible plants.

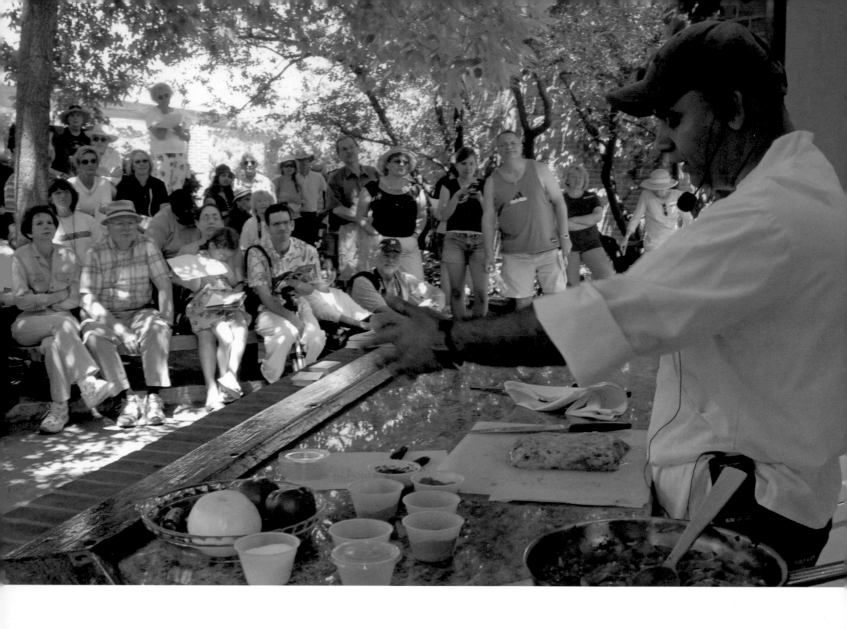

Resources and exhibits throughout the Regenstein Fruit & Vegetable Garden encourage learning. A live beehive provides an exciting opportunity to learn about the importance of pollination; the learning center is open for classes; volunteers interact with visitors and answer questions; the Wheelbarrow shop offers garden tools, kitchen supplies and gifts; and the open-air kitchen amphitheater brings the gardening cycle full circle as fresh produce becomes gourmet delight in the hands of renowned chefs.

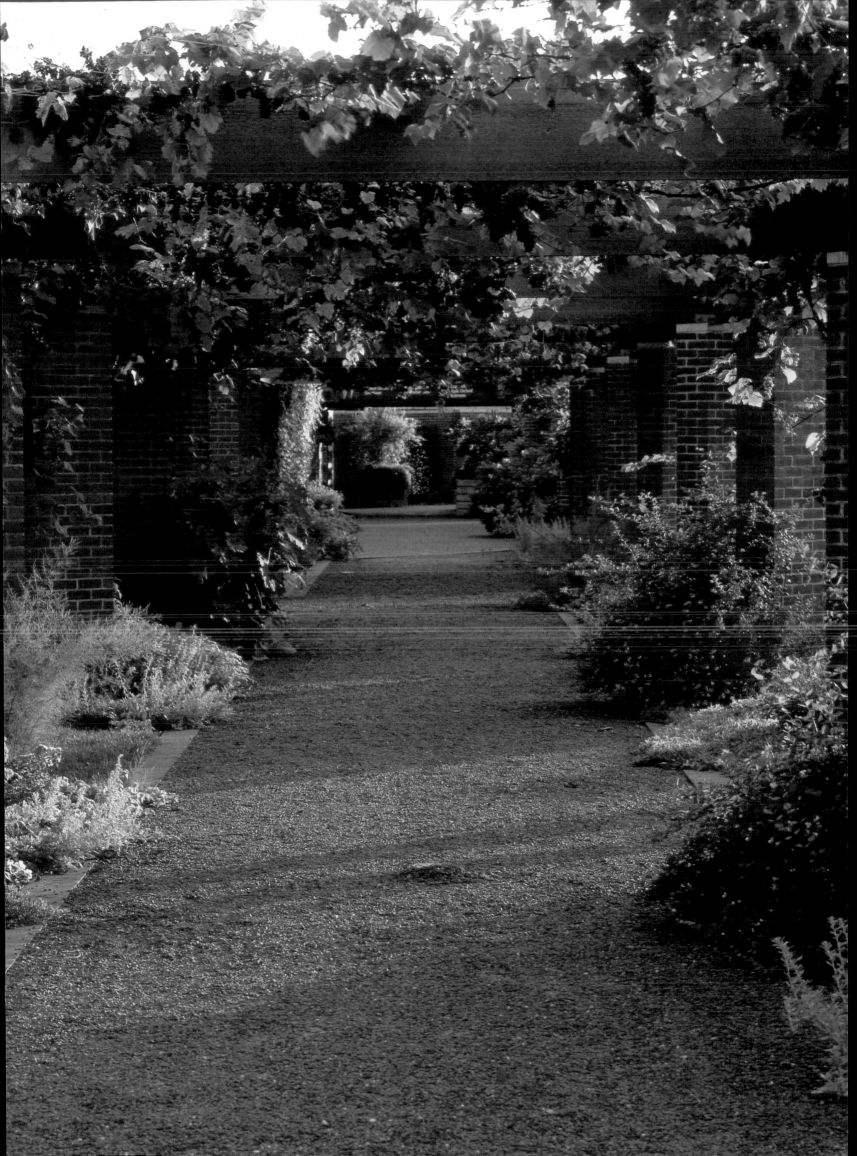

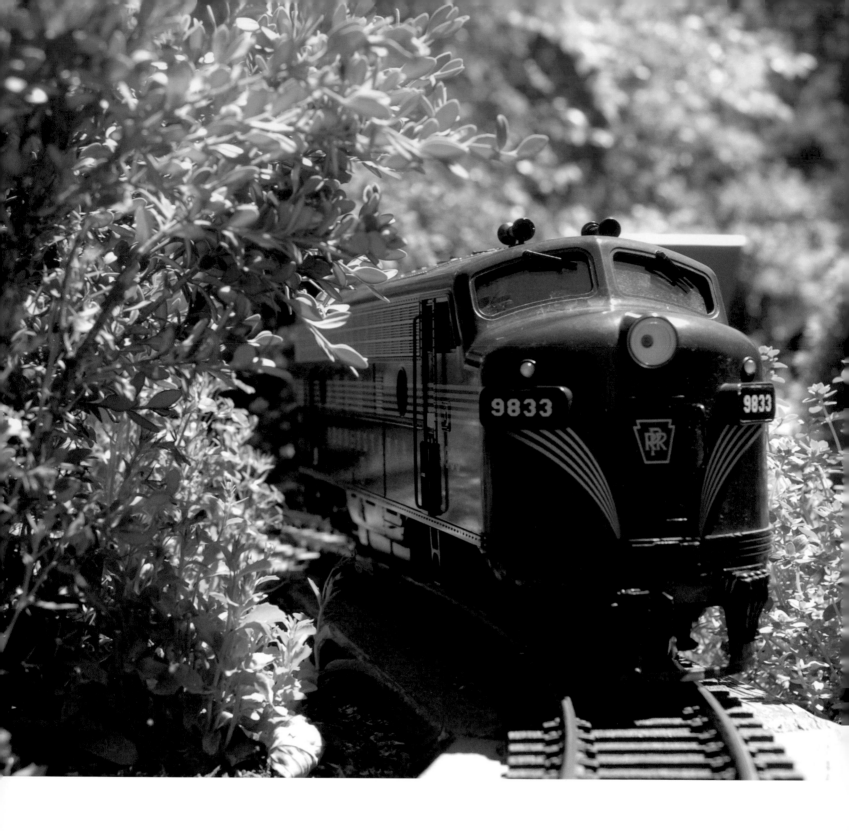

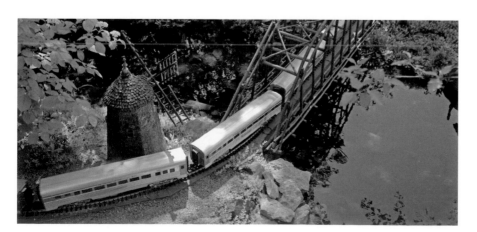

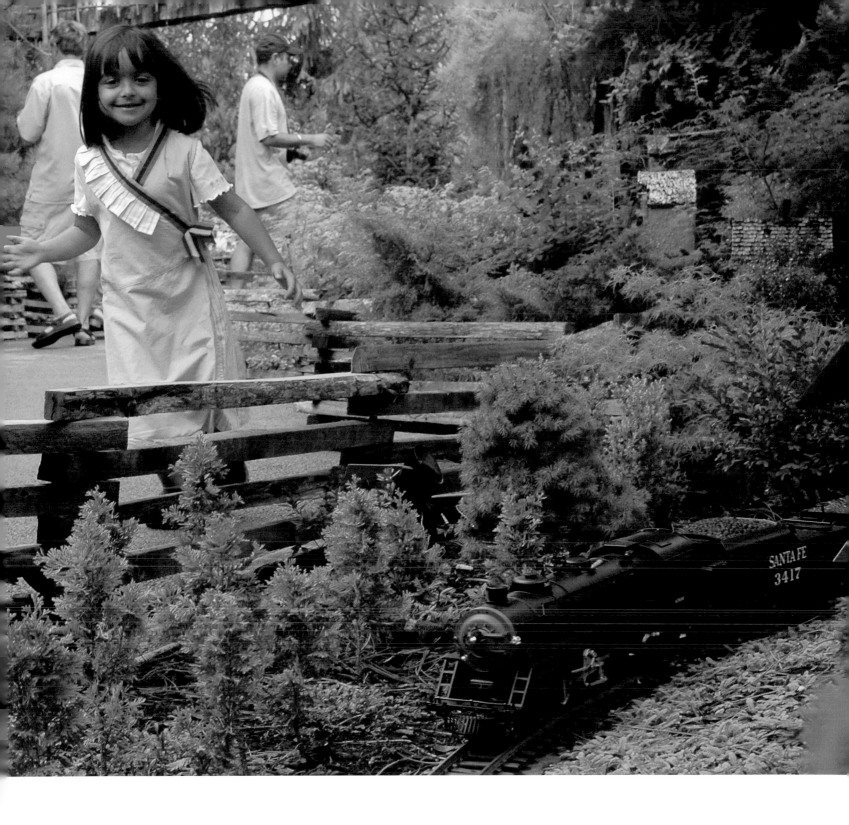

MODEL RAILROAD GARDEN Each year, designer Paul Busse adds new miniature American landmarks to expand this fully landscaped model railroad garden—to the delight of every family who visits. The 16 garden-scale model trains that whiz on overhead trestles or disappear into tunnels move through authentic American landscapes created from dwarf plants and plants expertly pruned to miniature size. Farmlands, vineyards, orchards, old-growth forests and sandy beaches are replicated using plants and exquisitely handcrafted natural materials. Tiny people, towns, rivers, sound effects and familiar landmarks transform this garden into a magical coast-to-coast travel experience.

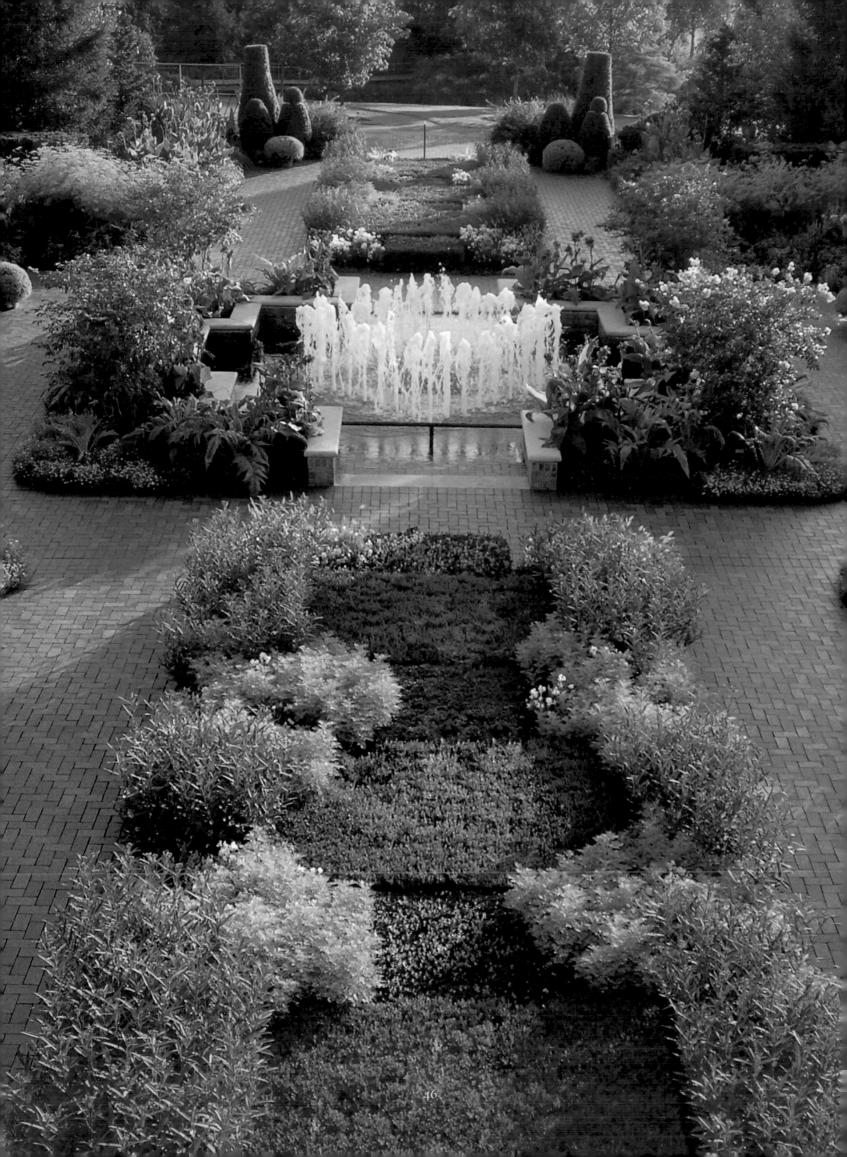

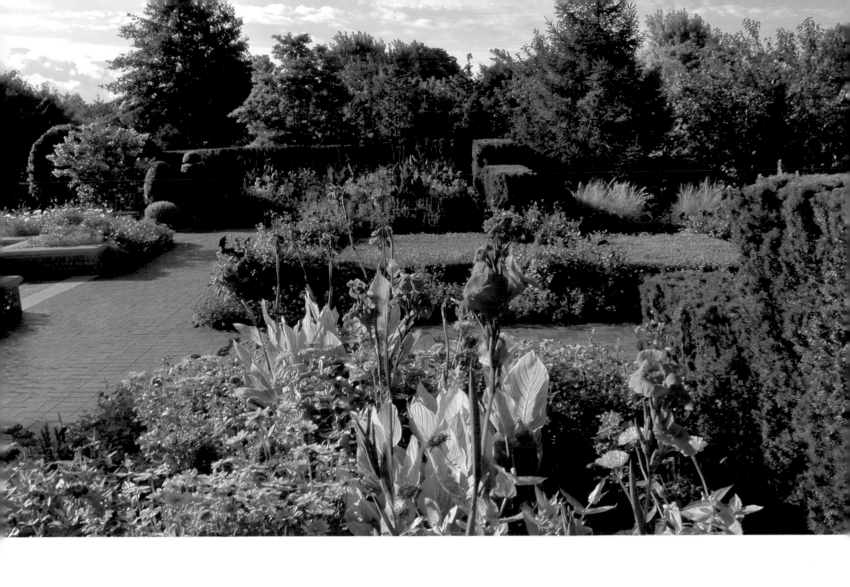

CIRCLE GARDEN Contained within one large circle are inspirational displays of flowering annuals at their most exuberant. Evergreens, boxwood parterres and yew hedges are the solid green backdrops to brilliant annual color as it is painted through three changing seasons. Early spring celebrates the beauty of bulbs underplanted with thousands of velvety pansies. Summer introduces heat-loving tropicals in exquisite combinations. Autumn features annuals in deep glowing colors, richly echoing the landscape-at-large.

This space contains surprises—two secret gardens on either side of the central fountain are ideal spots for dreaming. Wide brick paths, clipped topiaries and massed plantings emphasize the formality of the space, while playful water jets, arching grasses and bountiful annuals spilling onto the walkway point to a more relaxed garden style.

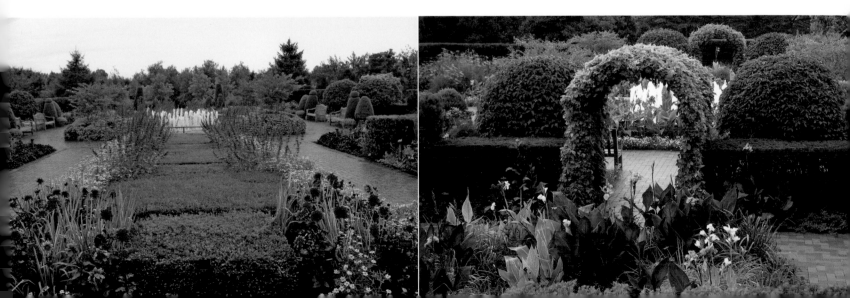

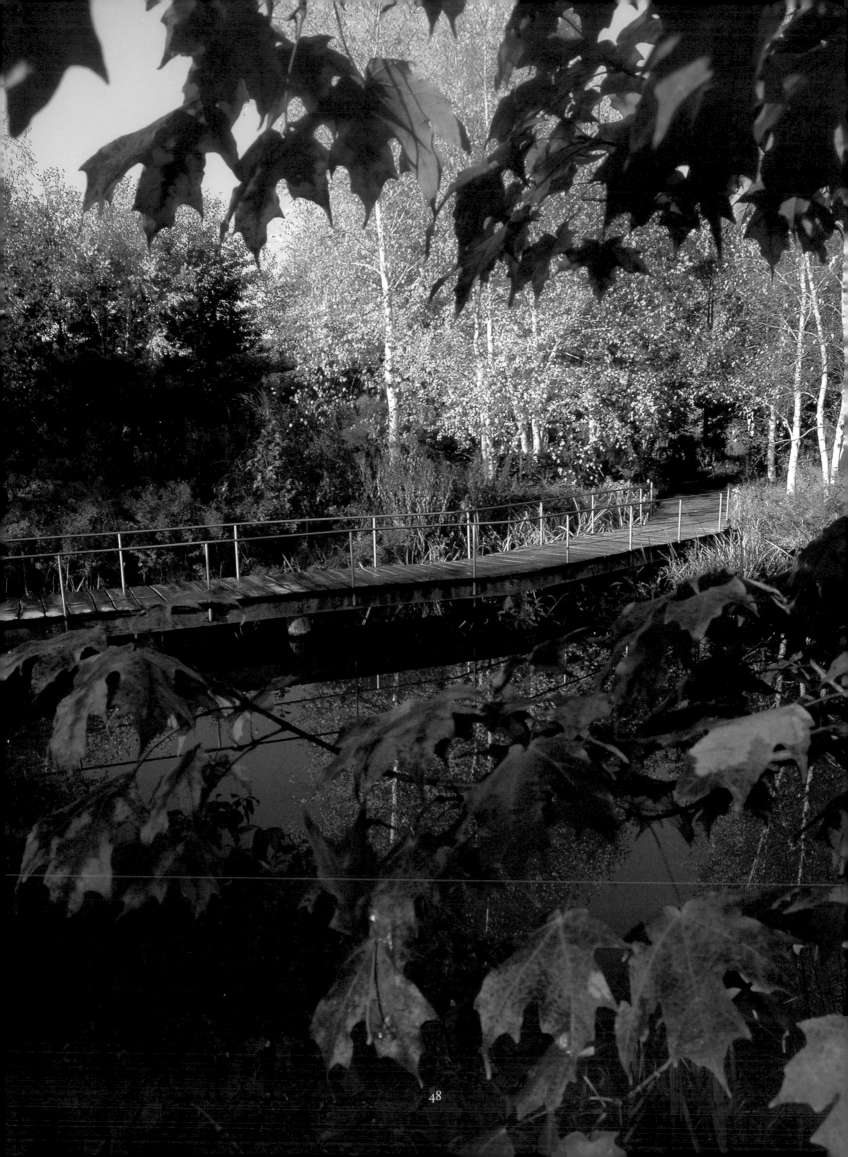

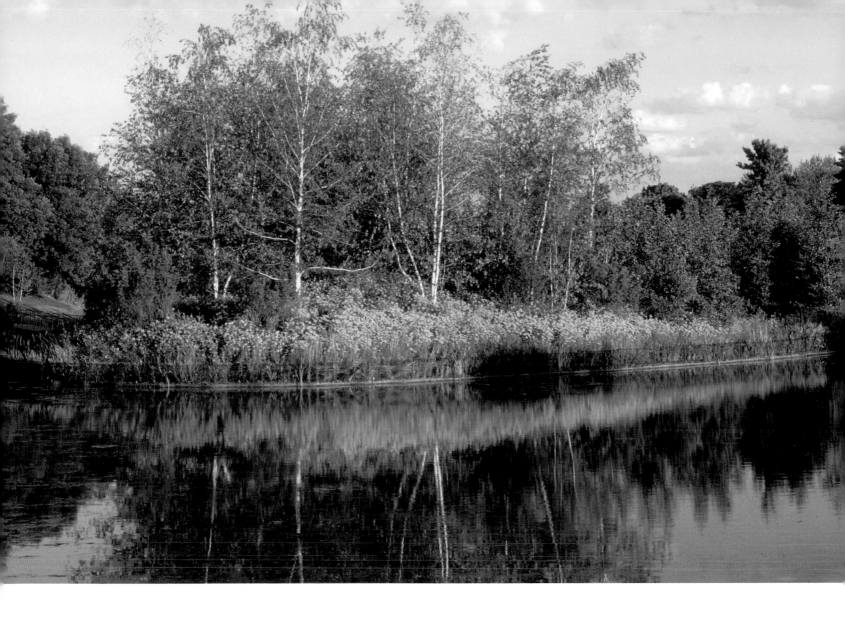

SPIDER ISLAND All forms of nature are celebrated in this intimate wooded isle designed by noted landscape architect Michael Van Valkenburgh. A handcrafted black locust boardwalk meets the island on an angle, creating a longer approach and a sense of anticipation of what is artfully concealed ahead. As the curling path wraps around the island's perimeter, allowing the visitor to experience both woods and water, it comes to a surprise ending—a secluded sitting area with dramatic views.

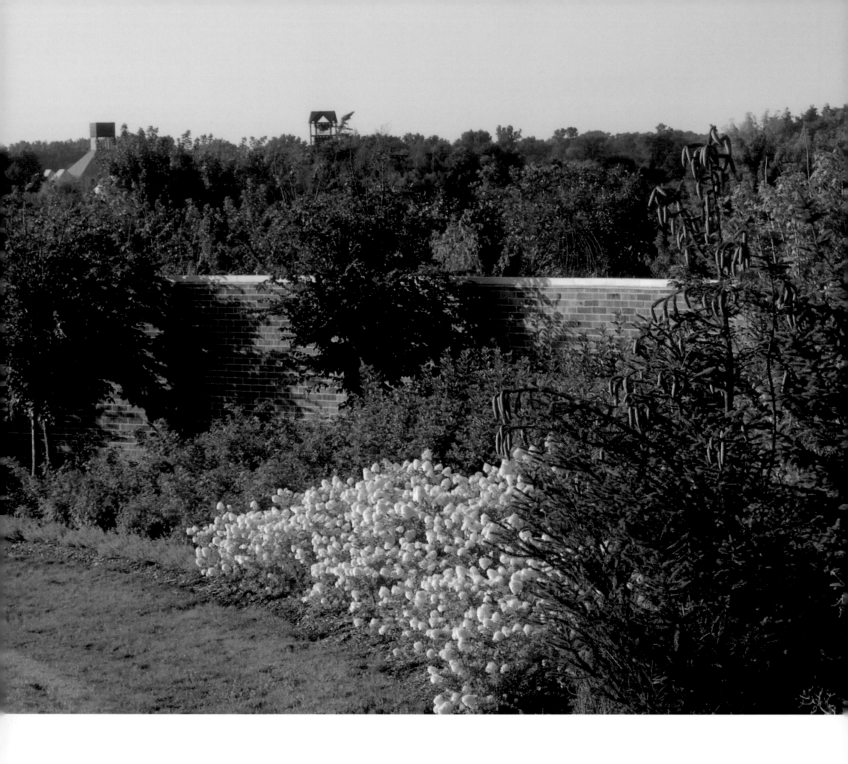

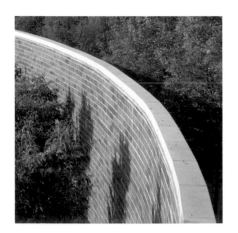
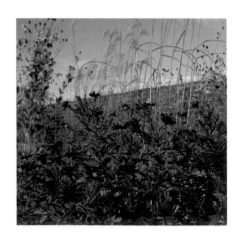
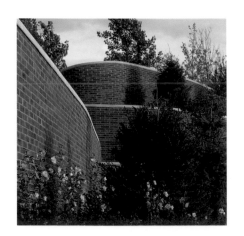

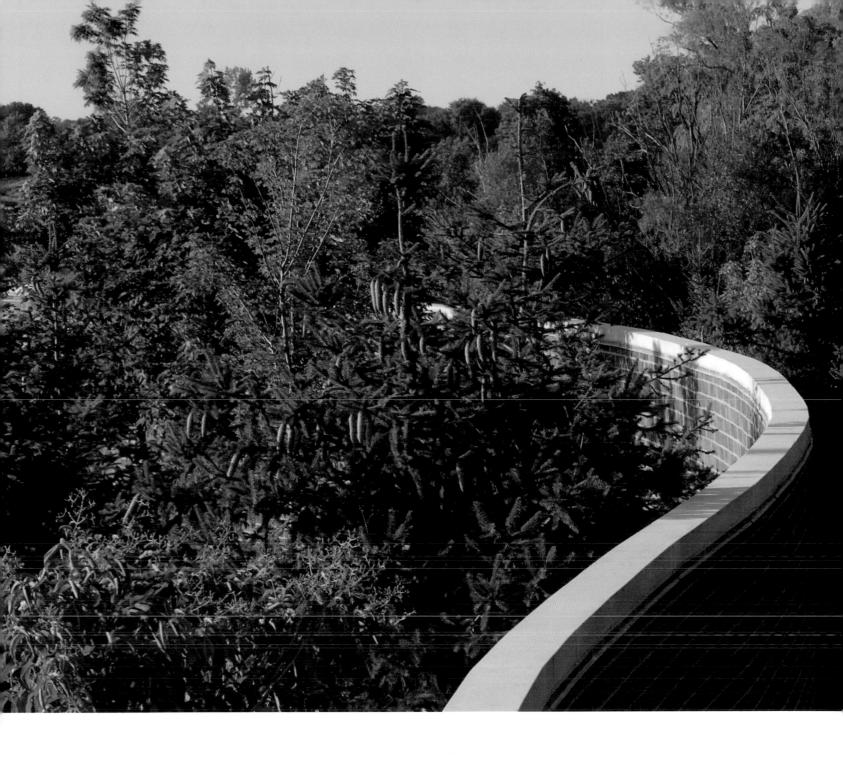

GARDEN WALL To reduce highway noise pollution and keep traffic visibility out of the Garden, a curving, terraced, 1.25-mile brick wall was built along the western edge of the Garden, richly landscaped on both sides with 28 acres of flowering trees, shrubs, roses, perennials, bulbs and ornamental grasses. Passing motorists on the Edens Expressway now experience a beautiful taste of what blooms inside, while Garden visitors appreciate a more tranquil experience.

Composed of 247,000 bricks laid by hand from 2004 to 2005, the wall is a unique example of a modern sound and visual barrier carefully designed to reflect the style of landscape seen throughout the Chicago Botanic Garden.

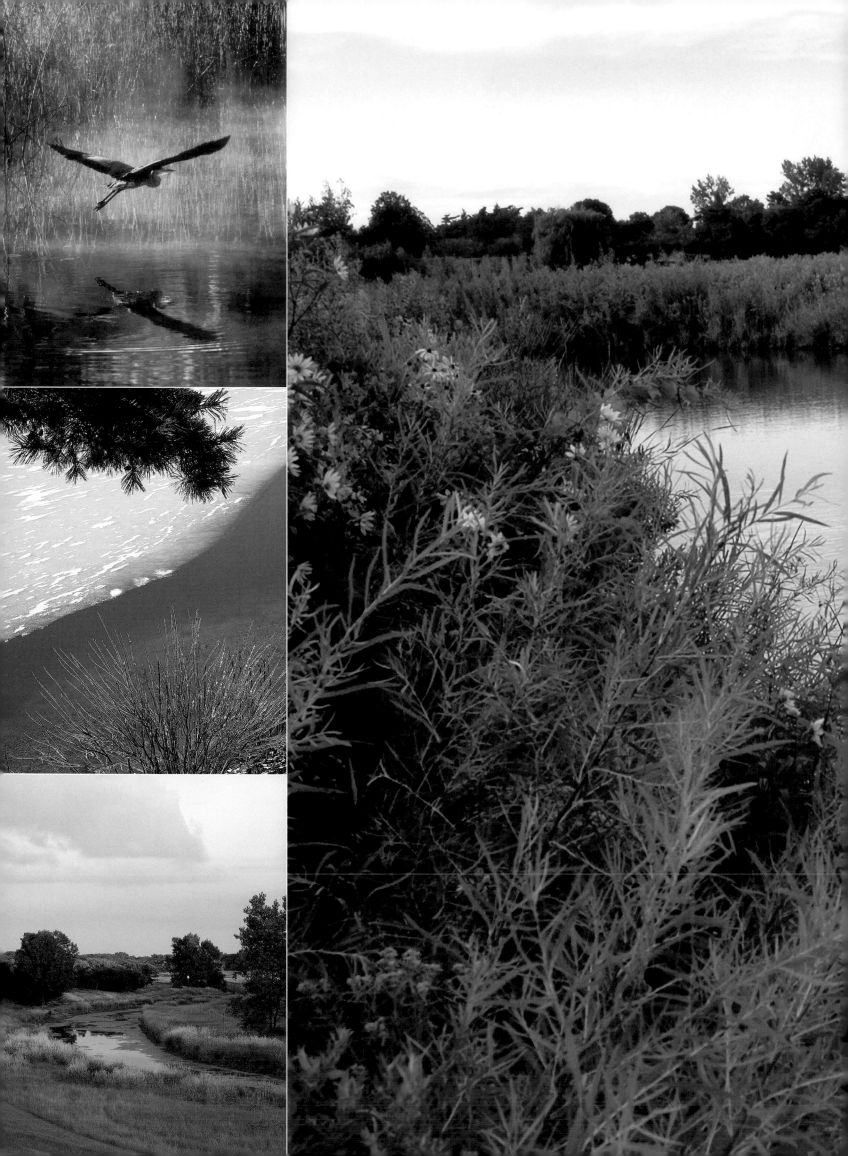

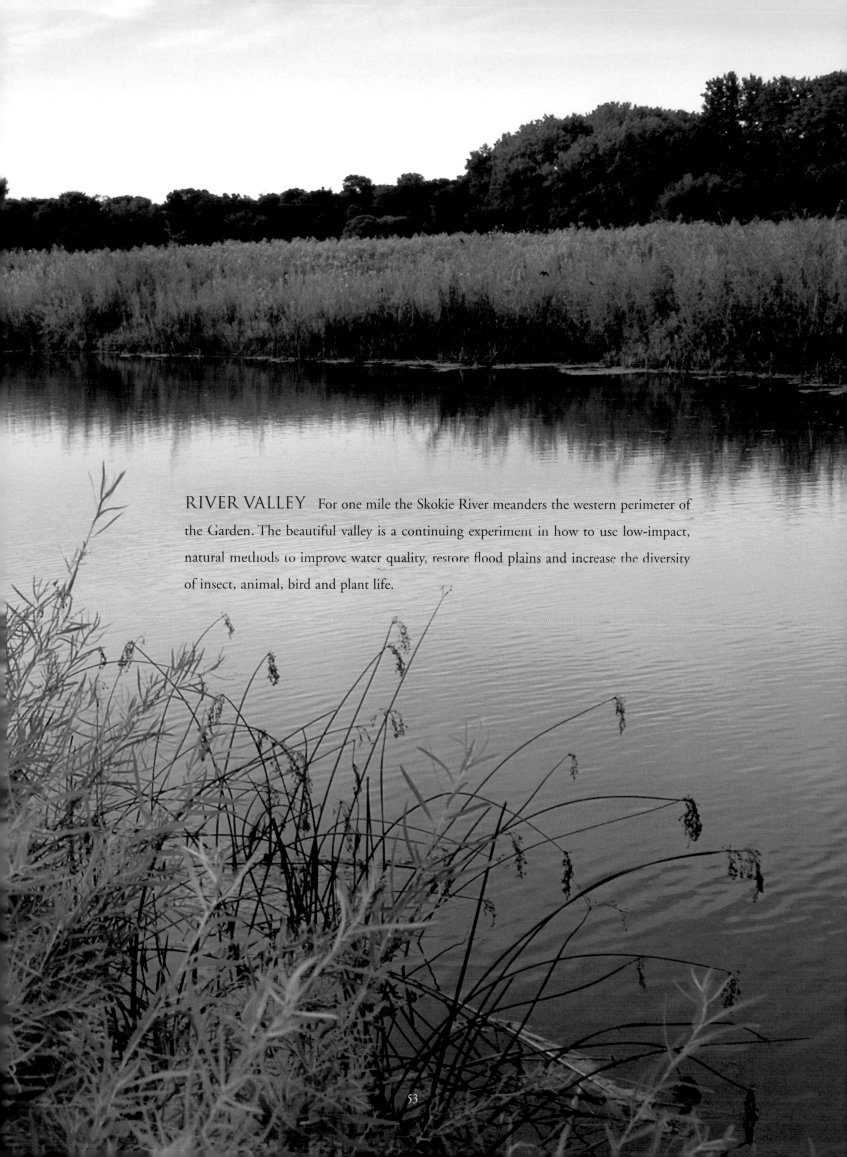

RIVER VALLEY For one mile the Skokie River meanders the western perimeter of the Garden. The beautiful valley is a continuing experiment in how to use low-impact, natural methods to improve water quality, restore flood plains and increase the diversity of insect, animal, bird and plant life.

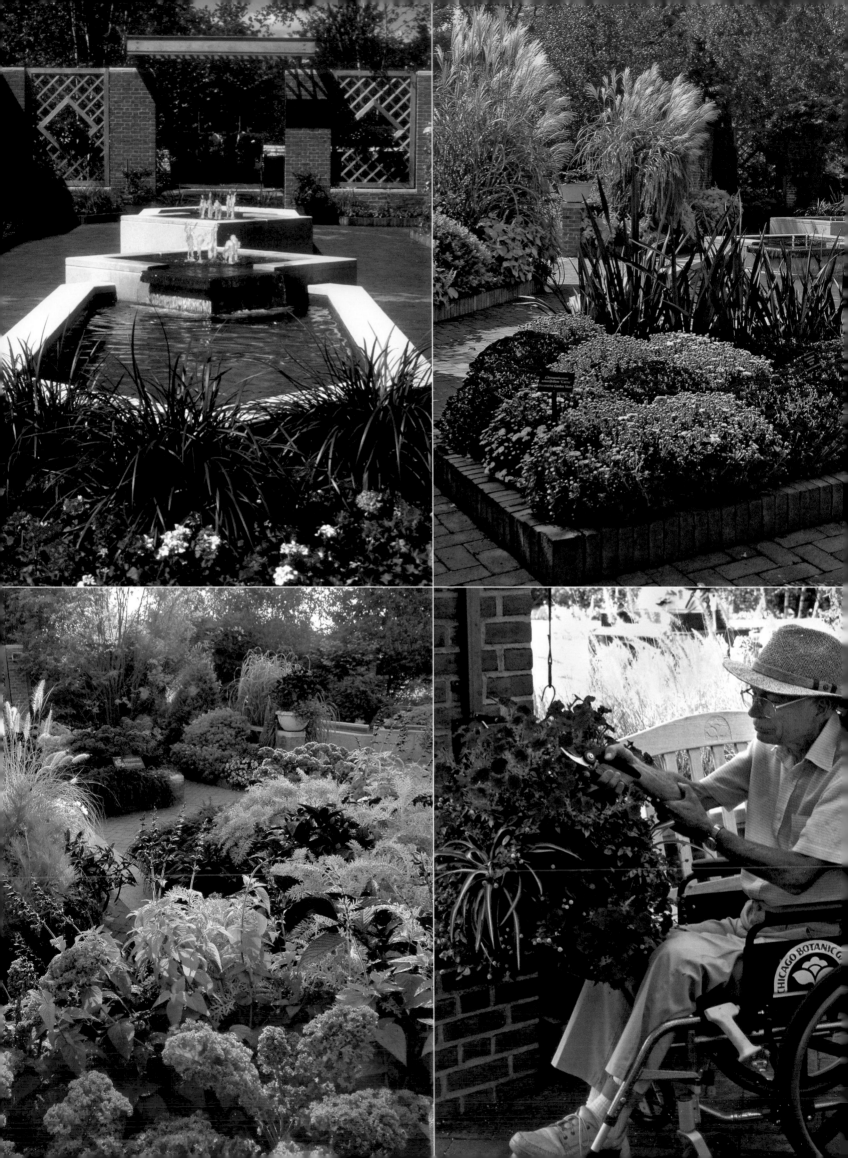

BUEHLER ENABLING GARDEN The Garden serves as a leader in the field of horticultural therapy, advancing the concept of accessible gardening to both home gardeners and human-service professionals. Buehler Enabling Garden is a stunning example of how a well-planned garden relates to people of all abilities.

Wide brick pathways permit easy access; raised beds, containers and vertical gardens bring the plants close to the gardener; and a creative selection of brilliant, textured and fragrant plants stimulate all senses. As is true throughout the Garden, water plays an essential role in enhancing the pleasures of the gardening experience.

This garden also serves as an educational programming site for workshops and horticultural therapy training sessions. The Tool Shed, a resource center located within the garden, offers a display of specialized tools and informative gardening fact sheets.

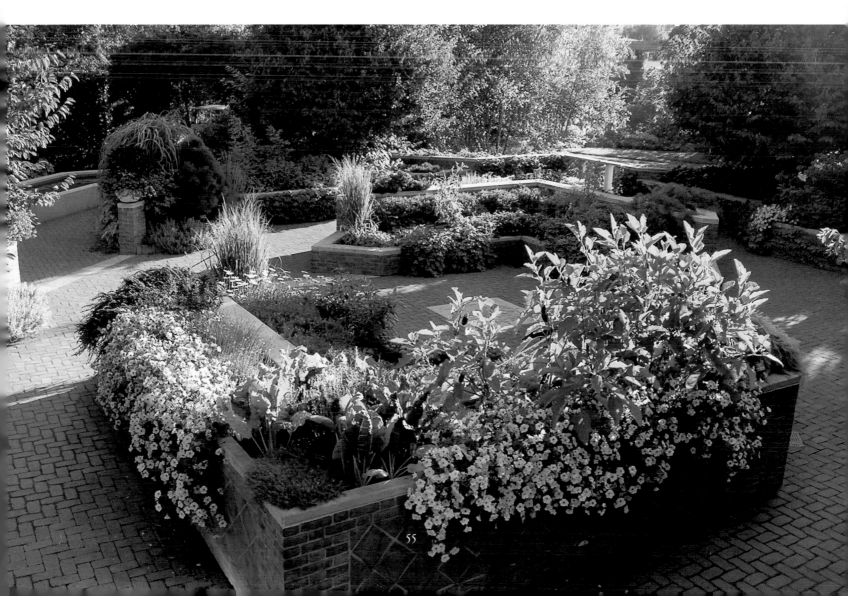

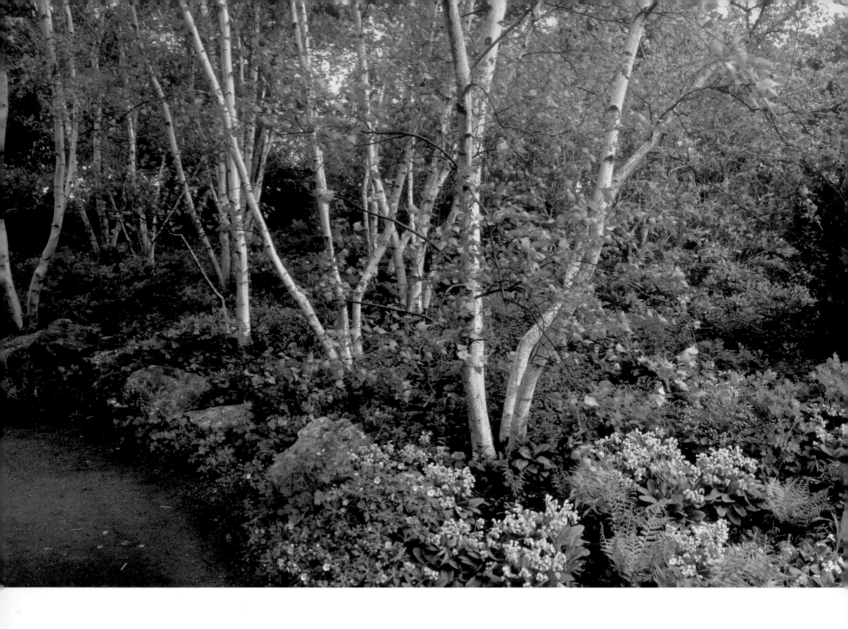

SENSORY GARDEN Plants engage all our senses with their color, fragrance, texture, even their movement and sound. Through a series of strolling paths, Sensory Garden encourages the exploration of the obvious, as well as the more concealed, sensory aspects of plants.

The brilliant plants in the raised beds of the upper walk invite caressing, inhaling and intimate viewing. The lower woodland walk envelopes the senses with alternating cool shade and warm sunny areas, interesting bark textures and fragrance. Birds, water and wind contribute further to the enjoyment of plants, in their ever-changing dimensions.

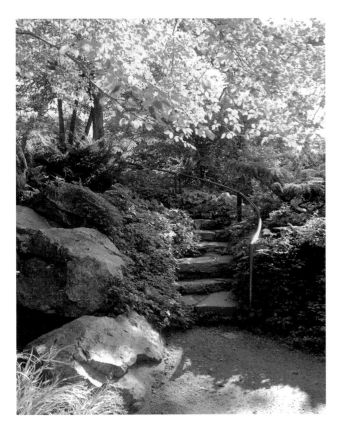

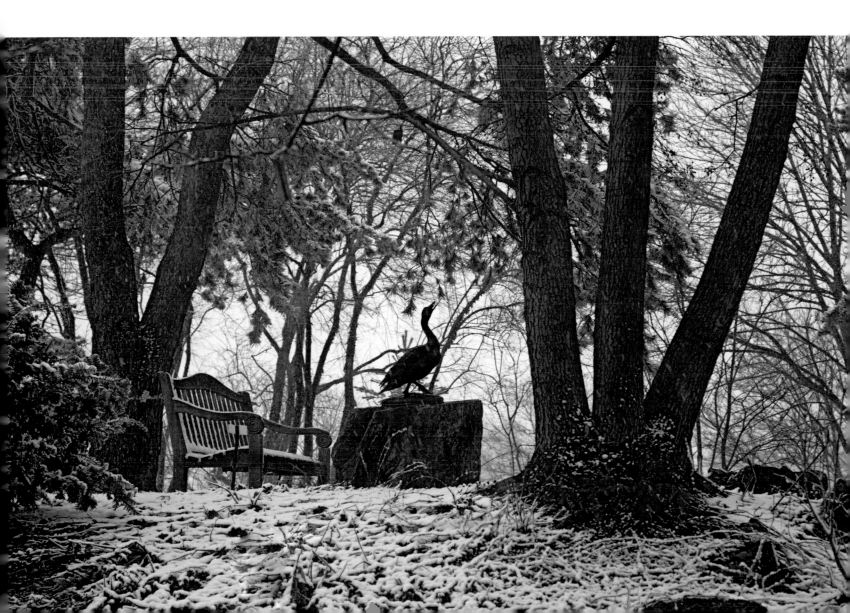

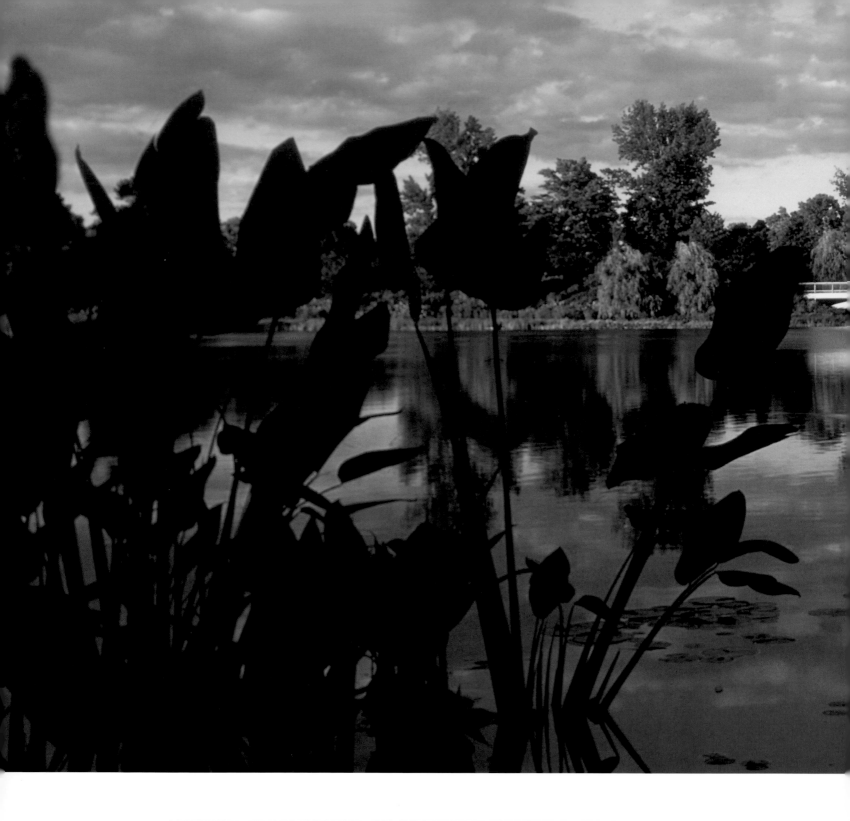
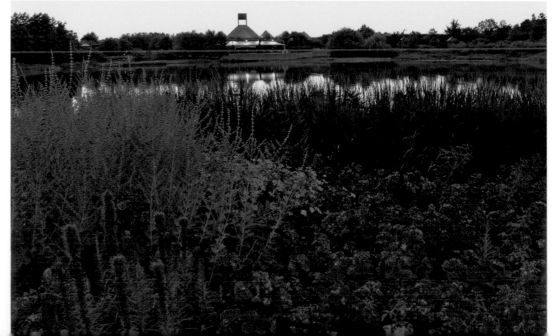

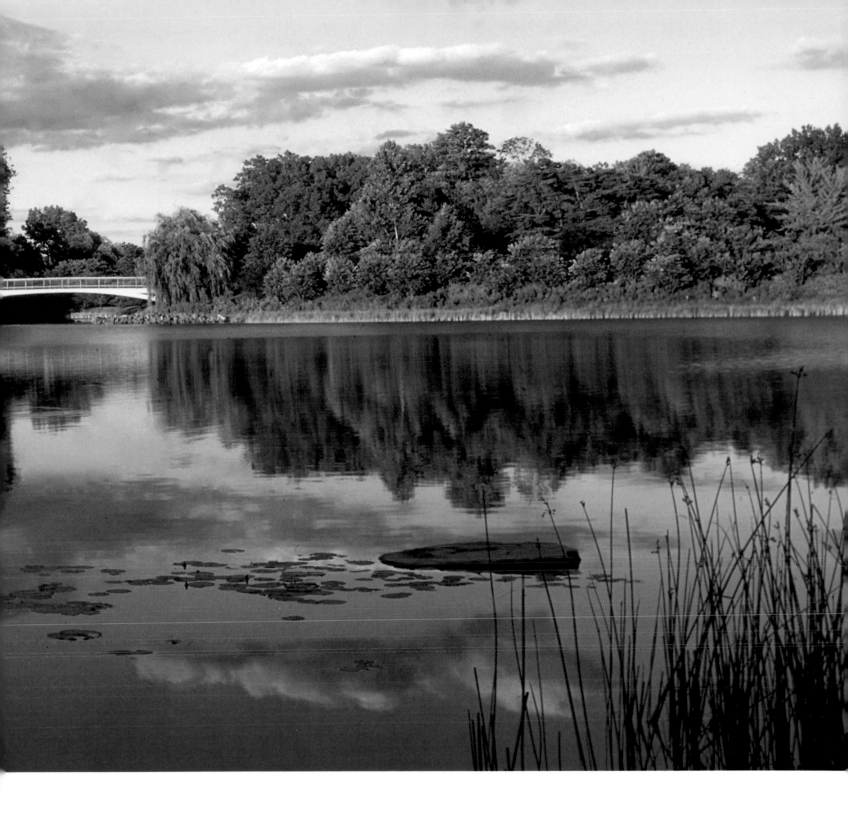

MCGINLEY PAVILION "Oh, wow, what a view!" defines this grand gathering space at the water's edge. Linked to Regenstein Center, surrounded on all sides by glorious gardens, it fully opens up to the Garden's central lake—the Great Basin—with panoramic views of the surrounding gardens.

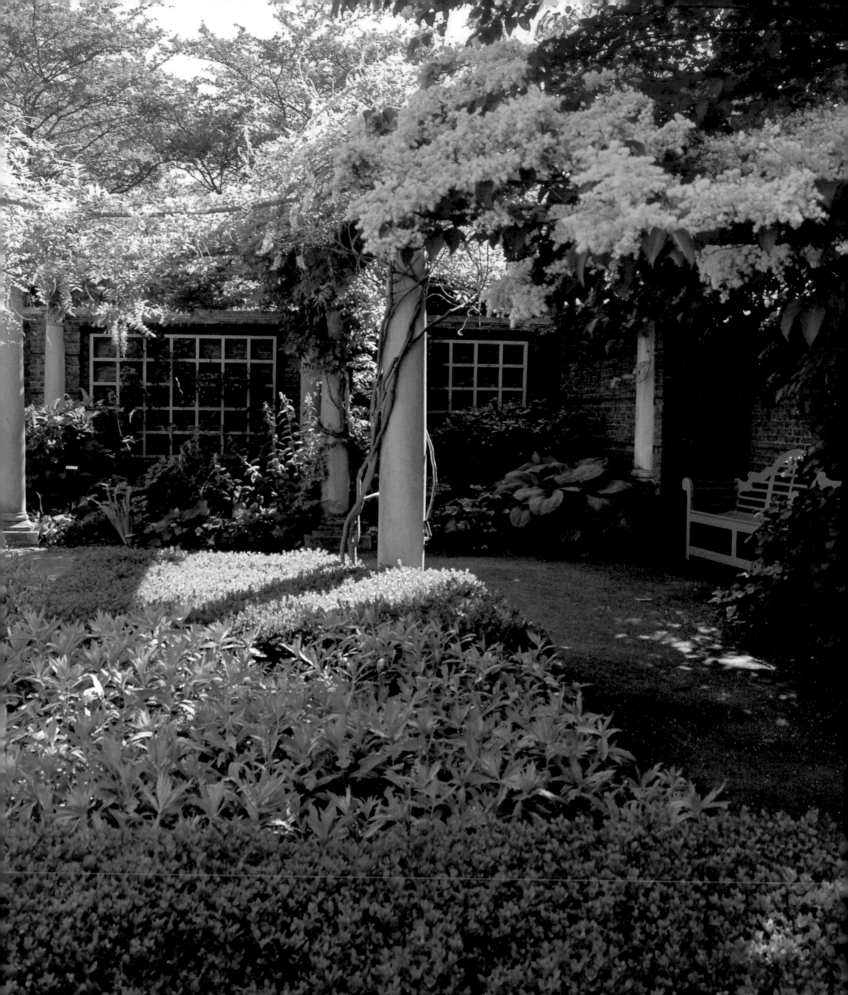

ENGLISH WALLED GARDEN

Enclosed by protective brick walls are charming, intimate garden rooms designed by British landscape designer John Brookes, each representing a different tradition from England's long gardening history. Important components include the pergola garden, promenade, checkerboard garden, an intimate urban courtyard, formal daisy garden, vista garden, perennial border and cottage garden. The very formal design is planted with a lush "English muddle" of herbs, bulbs, annuals and flowering shrubs and trees. The enclosing walls and hedges provide visitors with a private refuge, give way to views and vistas and provide many landscaping ideas for small spaces.

Enclosure is suggested using ingenious methods; floors and walls are created from textured materials that change from space to space. Crushed stone and brick pavers yield to warm wood and smooth cement—and finally to the surprise of living walls, fashioned from flowering vines and soft evergreen hedges. Secret peek-a-boo windows reveal framed glimpses of distant gardens.

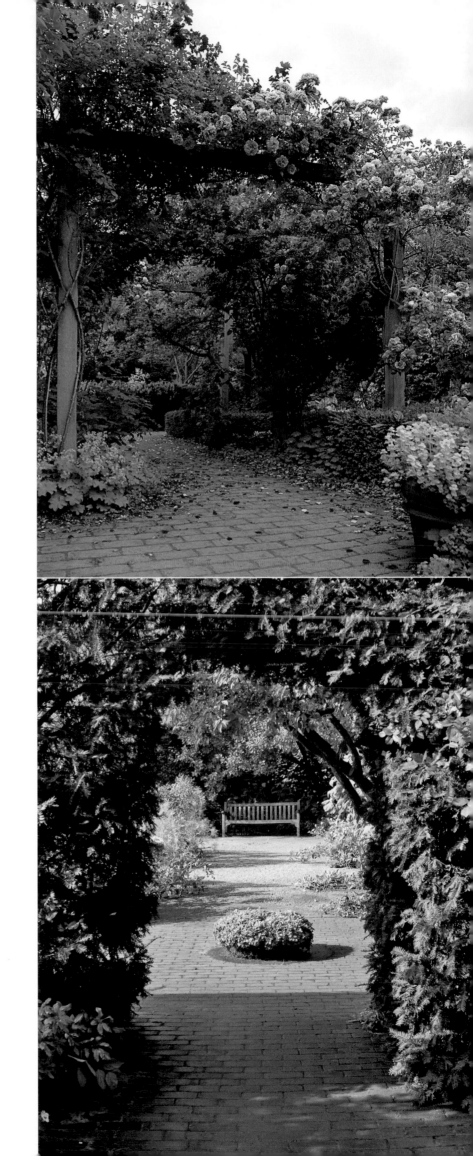

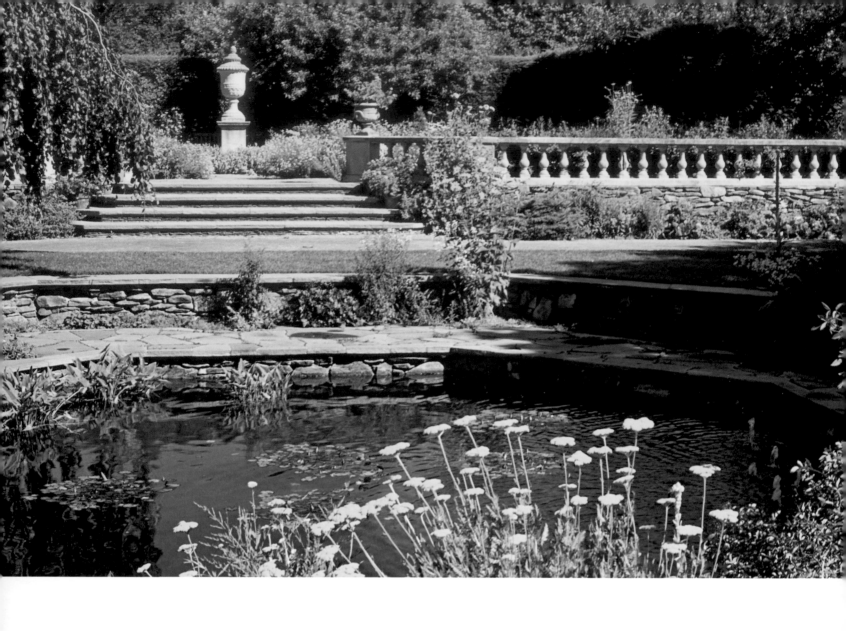

ENGLISH OAK MEADOW Nestled between the high points of Dwarf Conifer Garden and the rooms of English Walled Garden is a companion English garden space—a flowering hillside meadow filled with annual flowers and oak trees. The crushed granite walkway cuts a path through the slope, curving toward the Great Basin, offering stunning views of Evening Island and the gardens to the west.

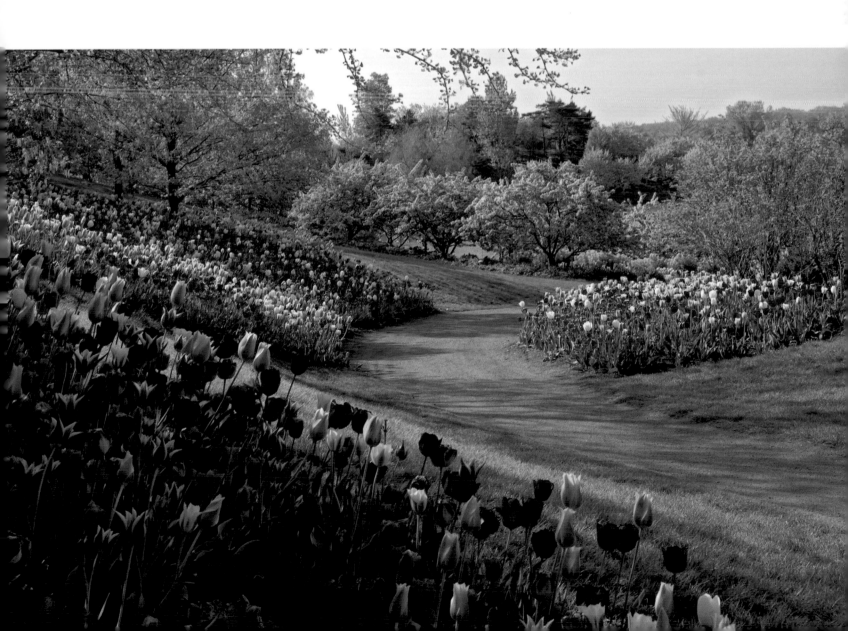

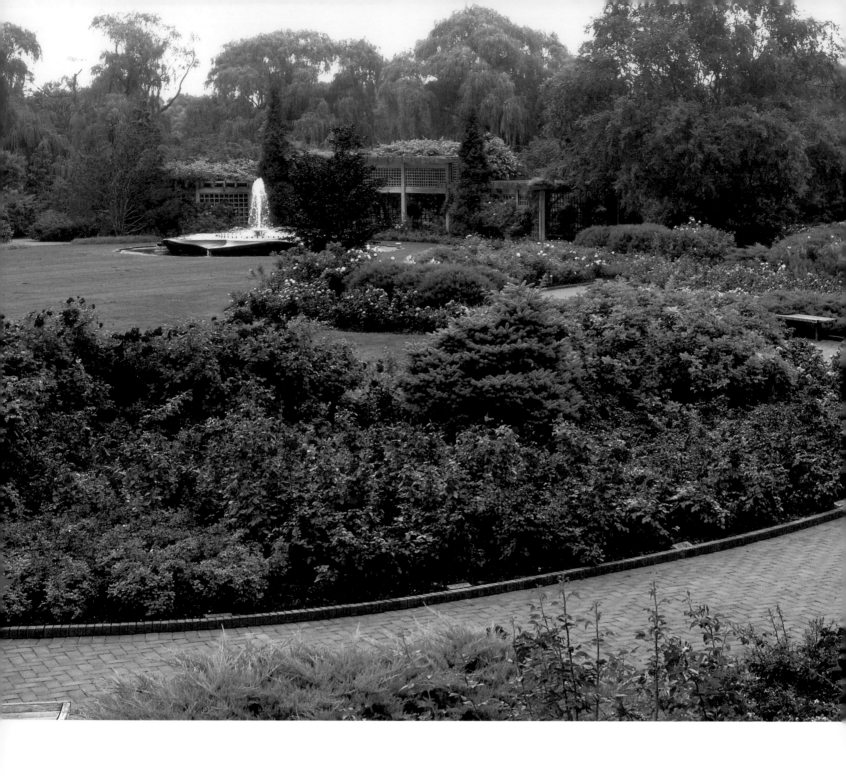

KRASBERG ROSE GARDEN That glorious moment in late spring, when 5,000 rosebushes come into bloom, is when all can understand why this flower is still America's favorite, celebrated in literature, history, cuisine, fashion and gardening.

The art and science necessary to grow to perfection top-performing roses in the Midwest are evident throughout the curving beds, where exquisite roses are paired with conifers, ground covers and flowering shrubs. The sweeping central lawn and rose petal fountain are lovely accents to the five-month flower show, which begins in spring and ends late in fall when hard frost colors the foliage and ripens the rose hips.

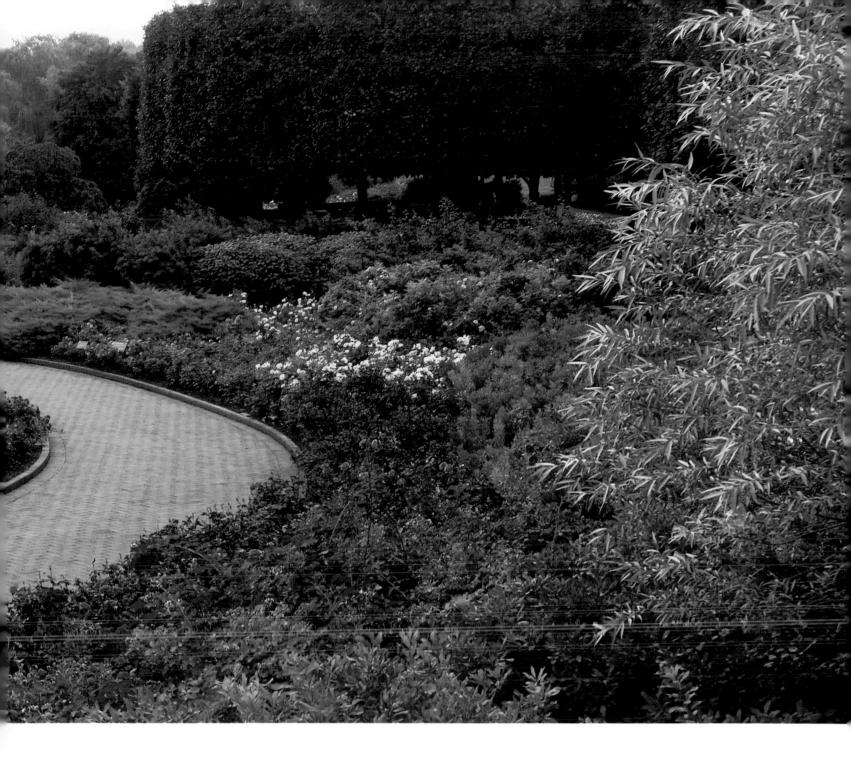

Strolling paths meander through three acres, inviting close-up, fragrant moments with new landscape roses, hybrid tea and hardy shrub roses, old-fashioned climbers, floribundas, multifloras and delicate miniatures, all highly recommended for the Chicago area.

Following pages: Linden Allée. An *allée* of 43 glowing Greenspire linden trees escorts visitors toward the Elizabeth Hubert Malott Japanese Garden. To maintain the crisp *allée*, trees are pruned twice a year, including a summer pruning done by hand—a job that takes six trained grounds-people 14 full days.

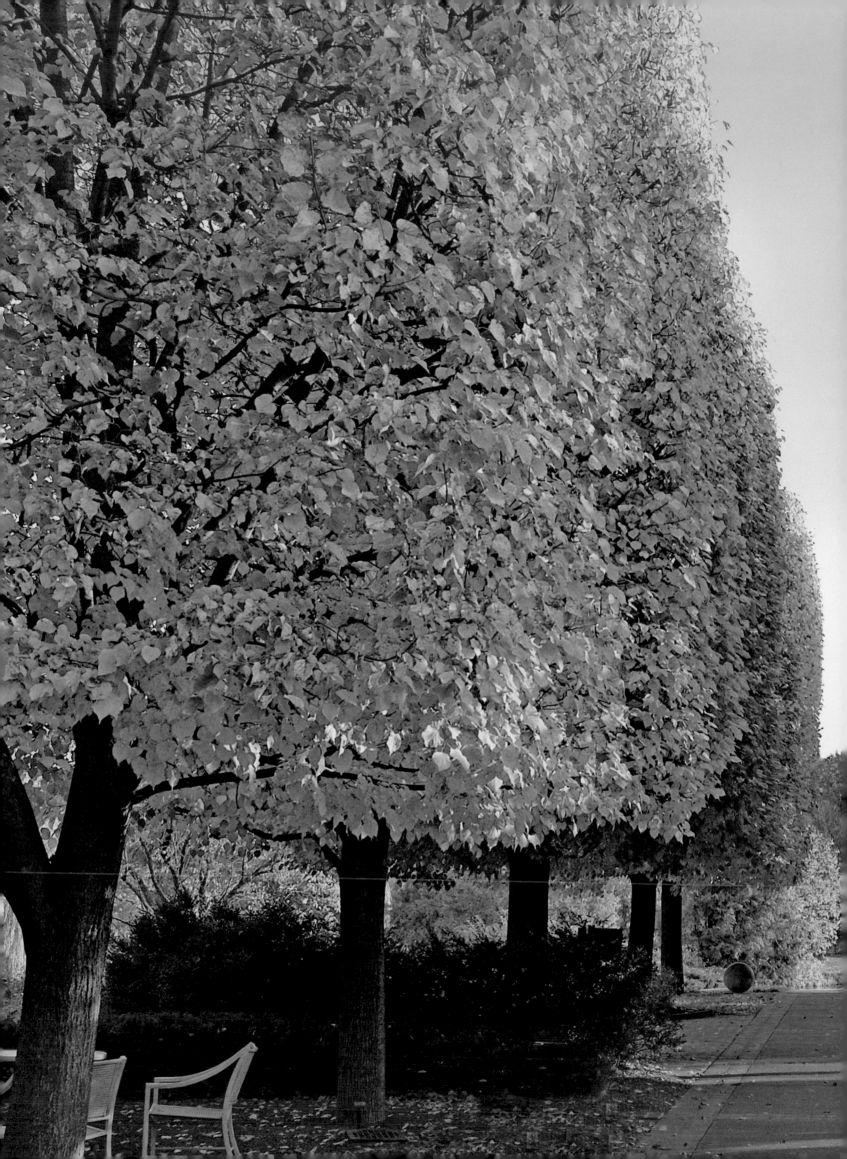

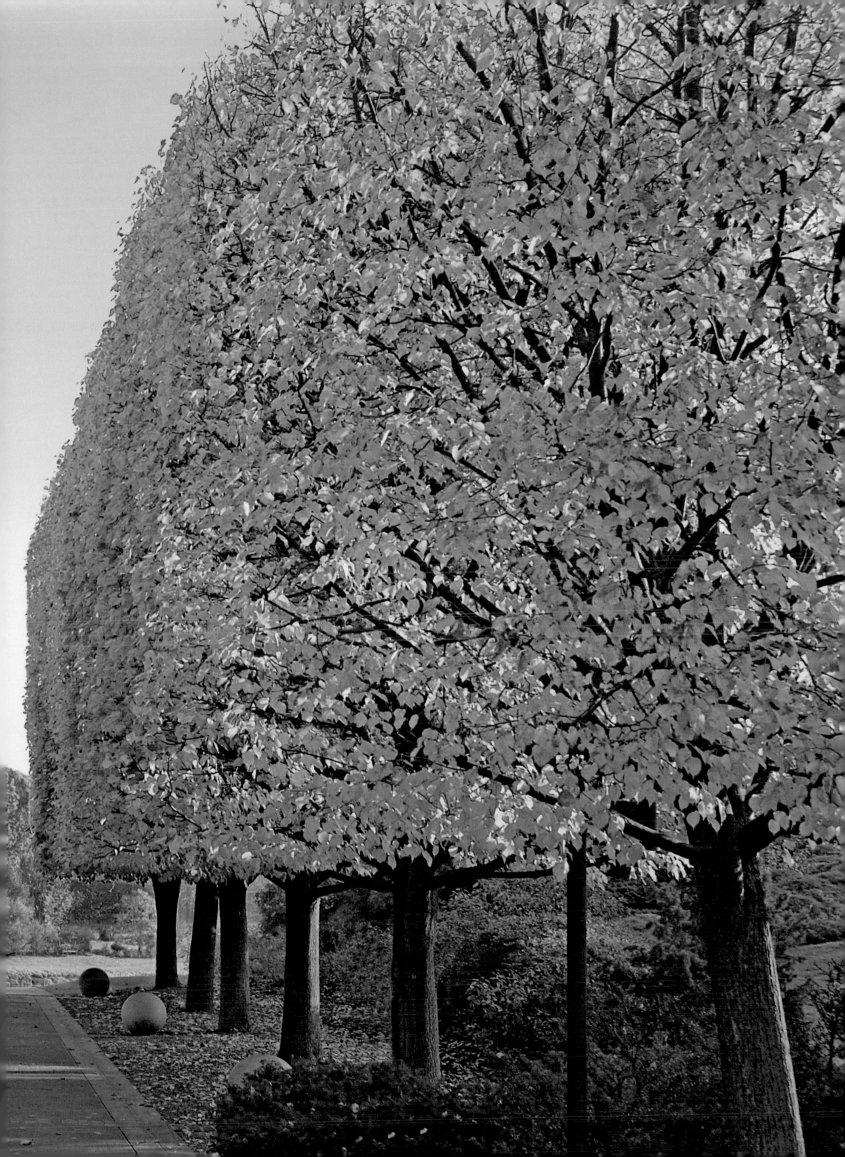

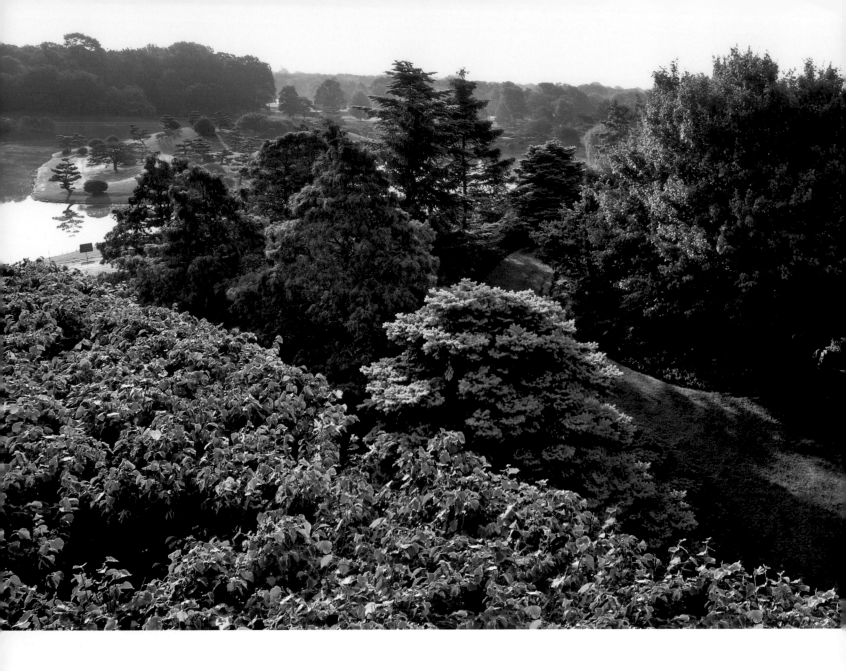

DWARF CONIFER GARDEN A peaceful garden of quiet beauty, a wonderland where plants can dazzle wearing fresh coats of snow—this is where it becomes clear why conifers are a Midwestern gardener's best friend. They bring structure, strength and texture, plus an exciting palette of colors in all four seasons. Landscape architect Douglas Hoerr designed the renovation of this garden, which demonstrates how slow-growing, dwarf trees and shrubs can have all the charm of their large counterparts, but take up much less space.

From chartreuse or powder blue to inky green or spun gold—the colors astound. Weeping or prostrate, rotund or feathered, they can become living fences, conceal unpleasant views or serve as solitary pieces of garden art. Birds find them as appealing as we do.

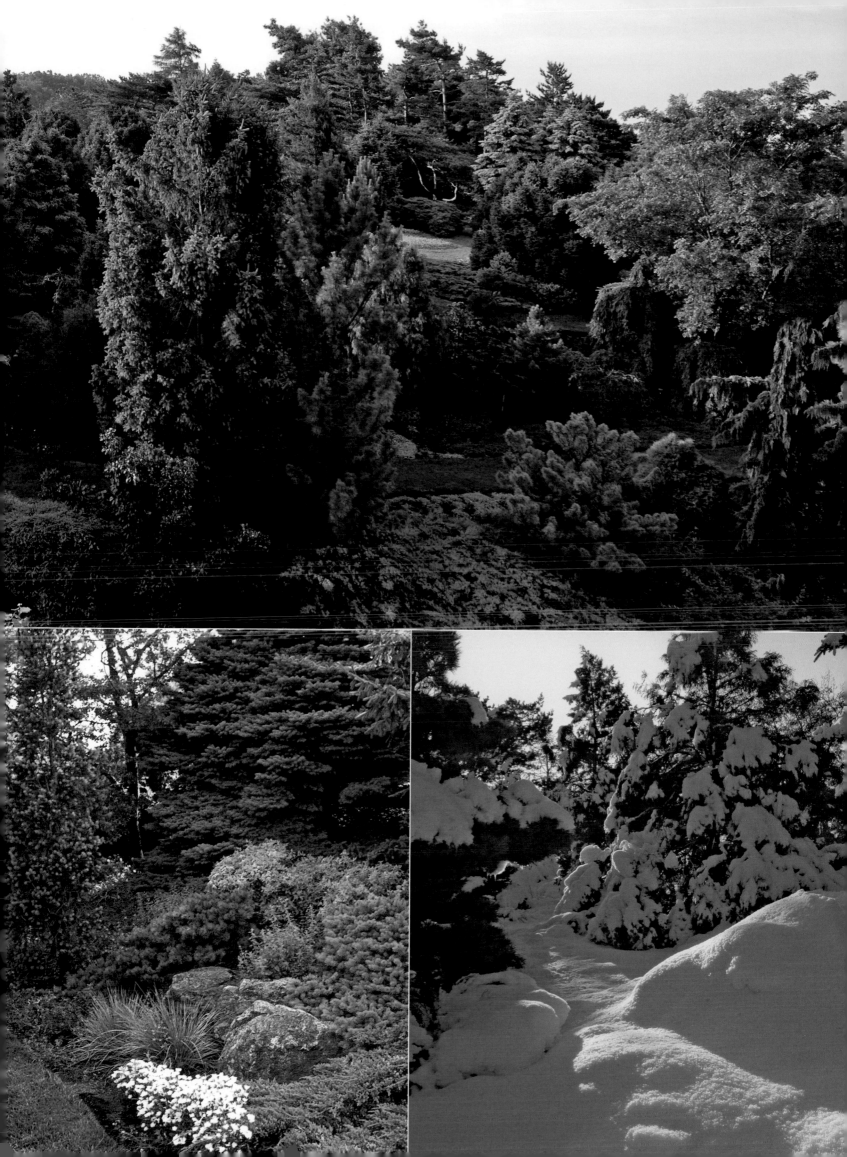

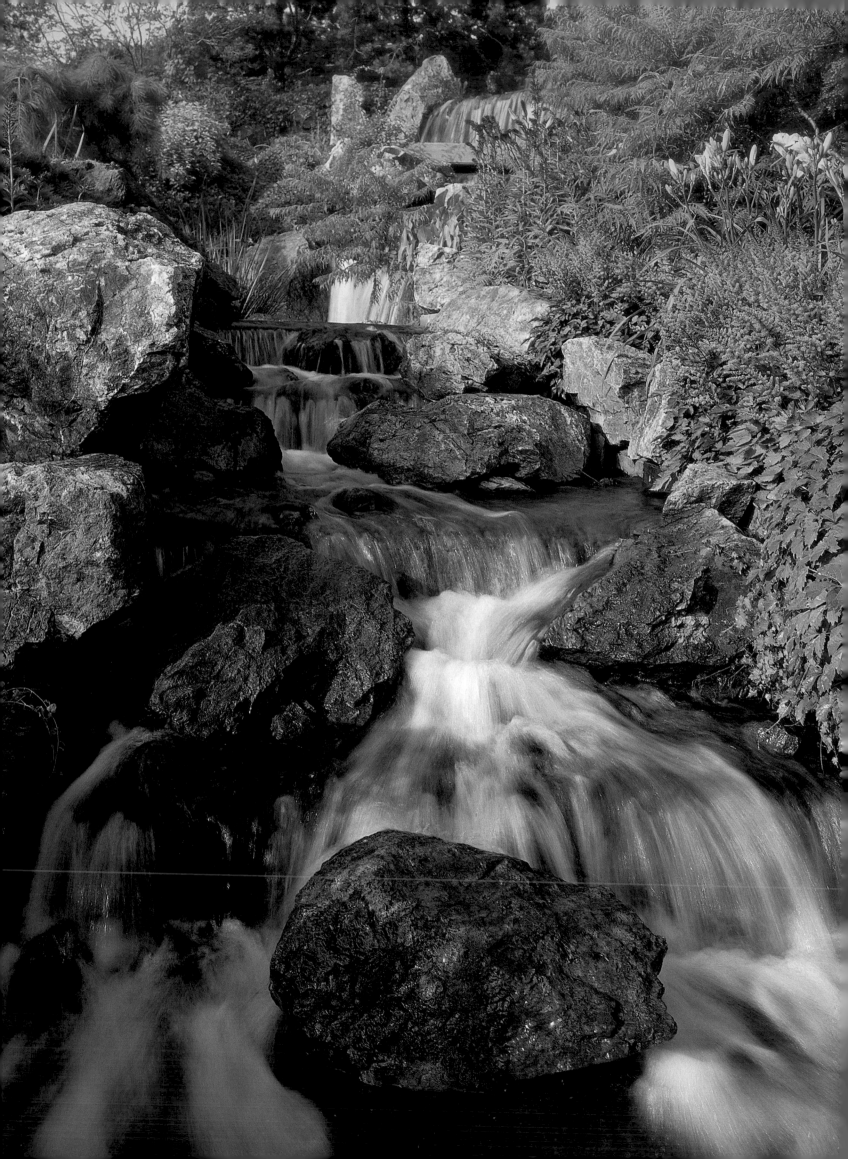

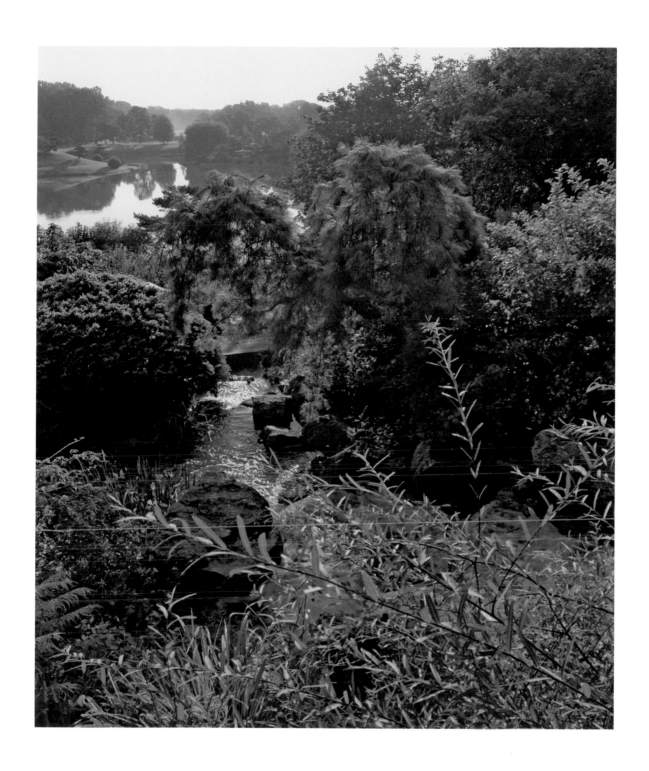

WATERFALL GARDEN The waterfall is a powerful creation of both humans and nature, tumbling majestically down 50 feet, rushing and cascading before pooling into the tranquil lake below. Recycled at 1,000 gallons per minute, the waterfall recalls a mountain stream, where pockets of conifers, shade-loving perennials and weeping trees emphasize the water's descending path.

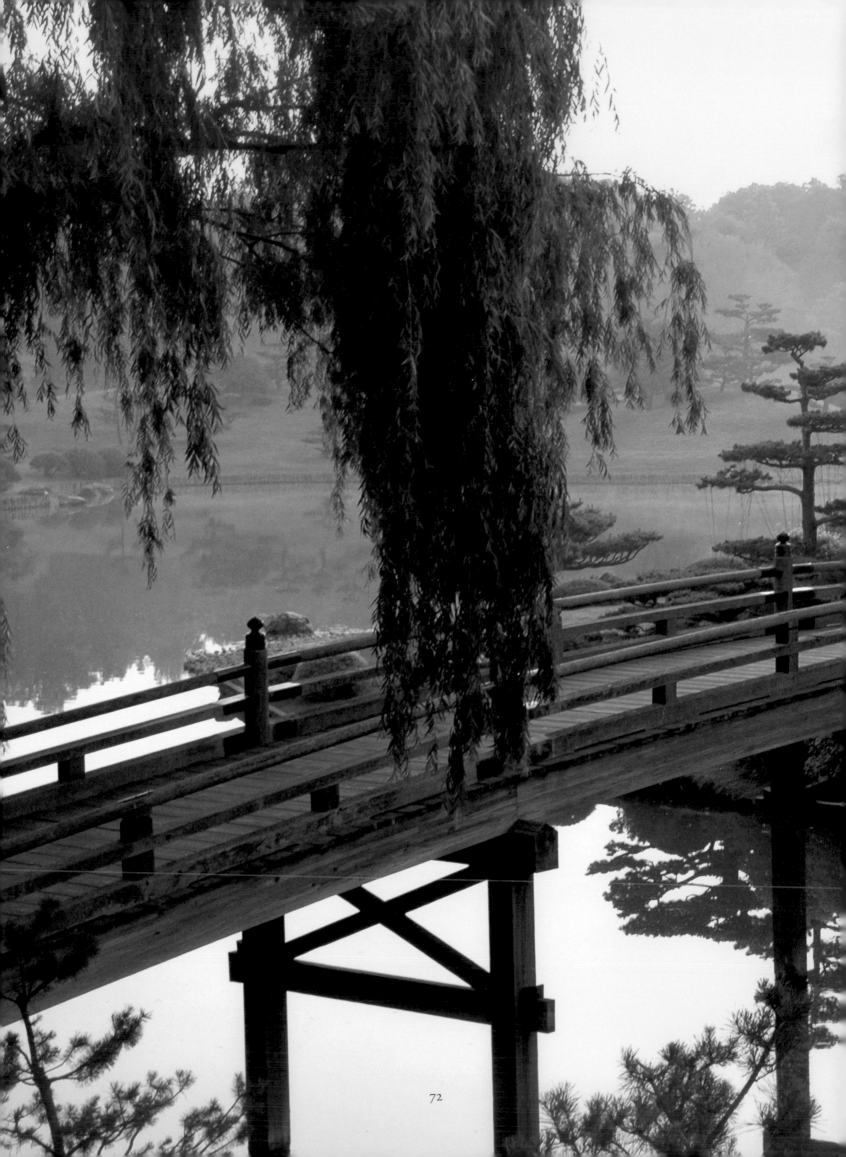

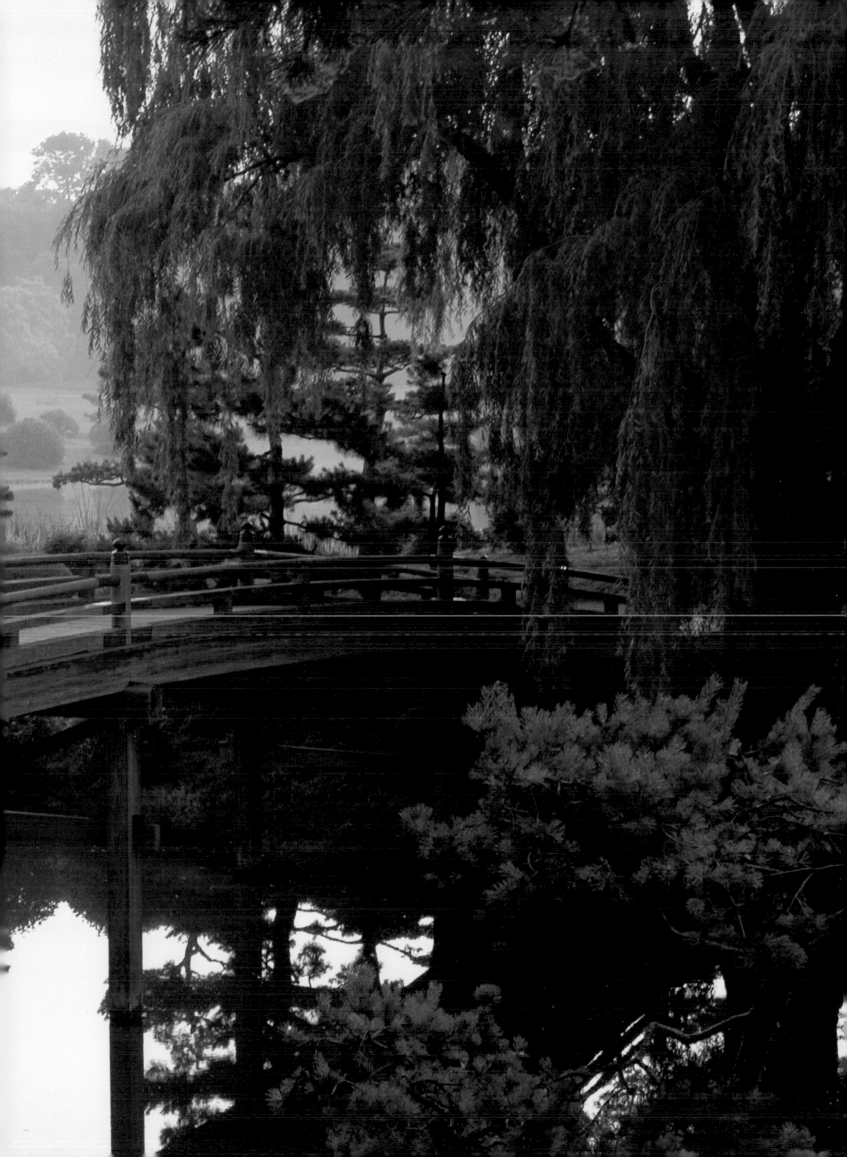

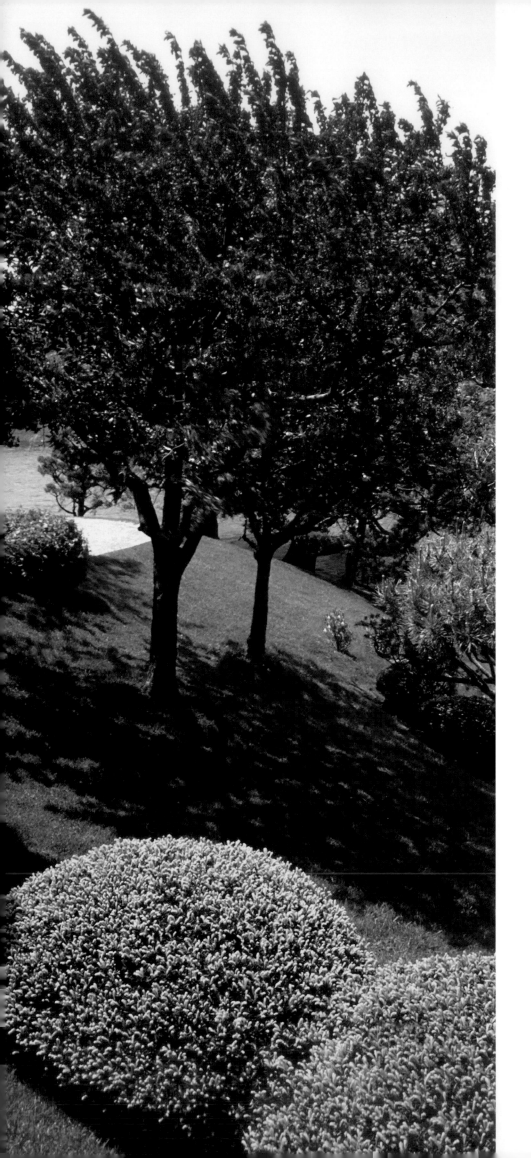

ELIZABETH HUBERT MALOTT JAPANESE GARDEN

Sansho-En, Garden of Three Islands, is a place of beauty and tranquility, where visitors can experience the aesthetics, culture and gardening style of another country. The journey begins at the bridge and continues along the path to garden paradise. Designed by Dr. Koichi Kawana as a stroll garden where paths curve, pause and break to slow the pace, the garden allows the landscape's inherent beauty, whether on the ground or across the water, to be slowly revealed. The first two islands welcome visitors, but the third, Island of Everlasting Happiness, can only be contemplated from a distance, since it represents a paradise inaccessible to mortals.

Plants are tightly pruned to complement hard, craggy rocks or imitate tree-covered hillsides. Boulders representing the bones of the earth are placed first in the garden, taking precedence over the plants. The gently raked stone gravel of the dry garden mimics water currents, while carefully positioned stones provide the pathway to shelter across these waves.

Japanese gardens are to be enjoyed in all seasons. In winter, plants covered with snow assume new identities, blurring the lines between reality and suggestion. Lengthening tree shadows glide across the snow creating a shadow garden never seen in summer. Pine trees are pruned to frame views of distant scenes. When a plant comes into bloom, whether cherry, azalea, iris or chrysanthemum, it becomes the object of all attention and admiration. Stone

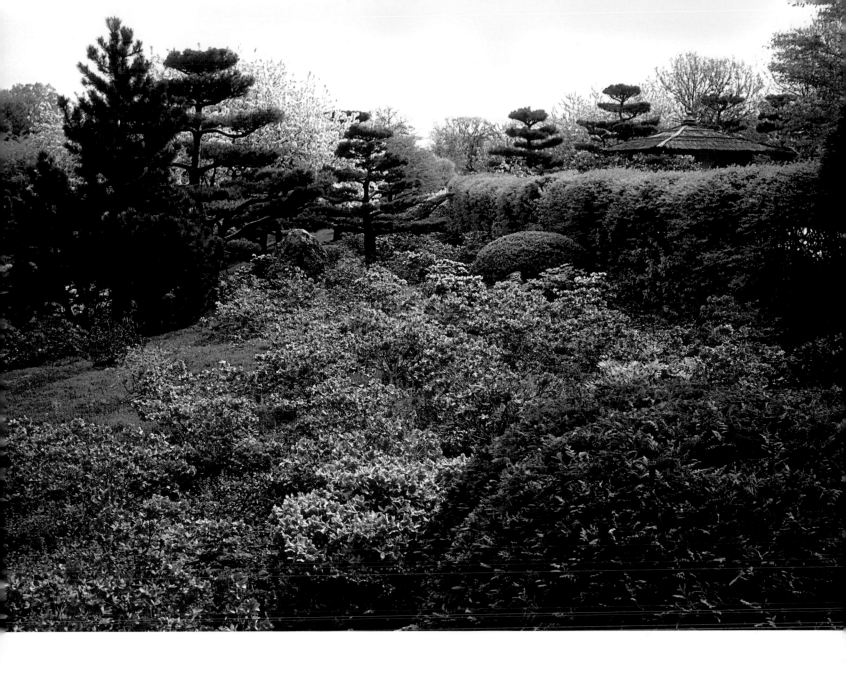

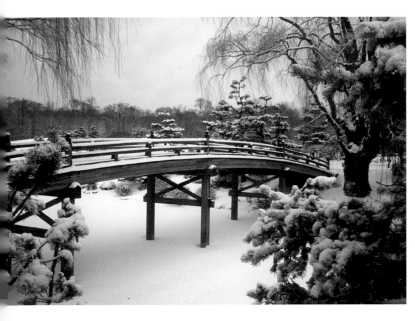

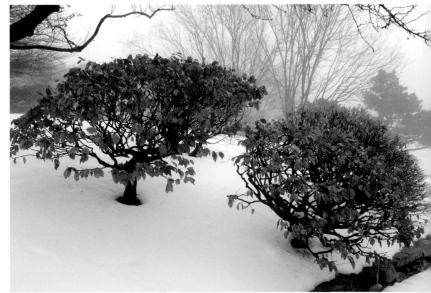

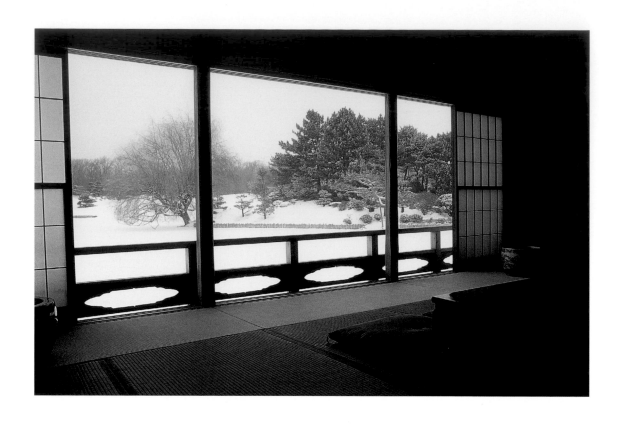

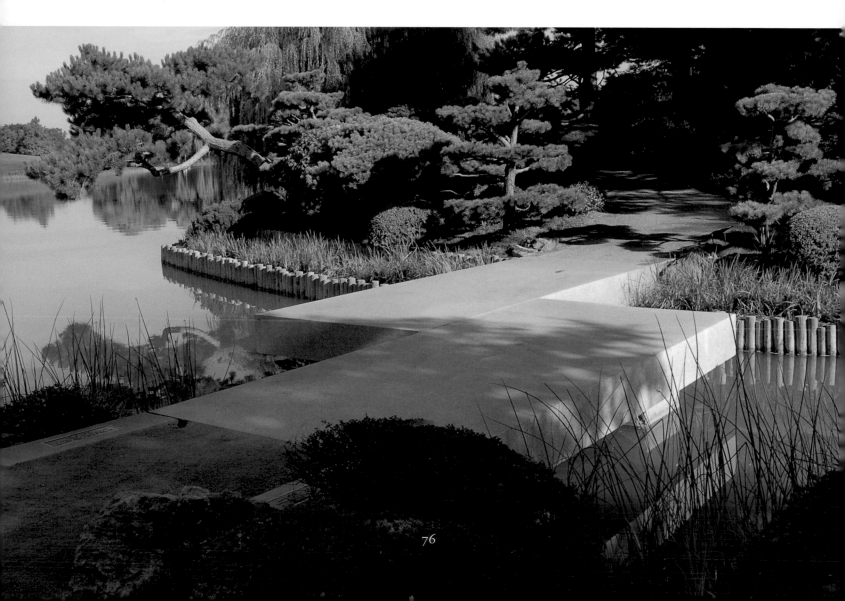

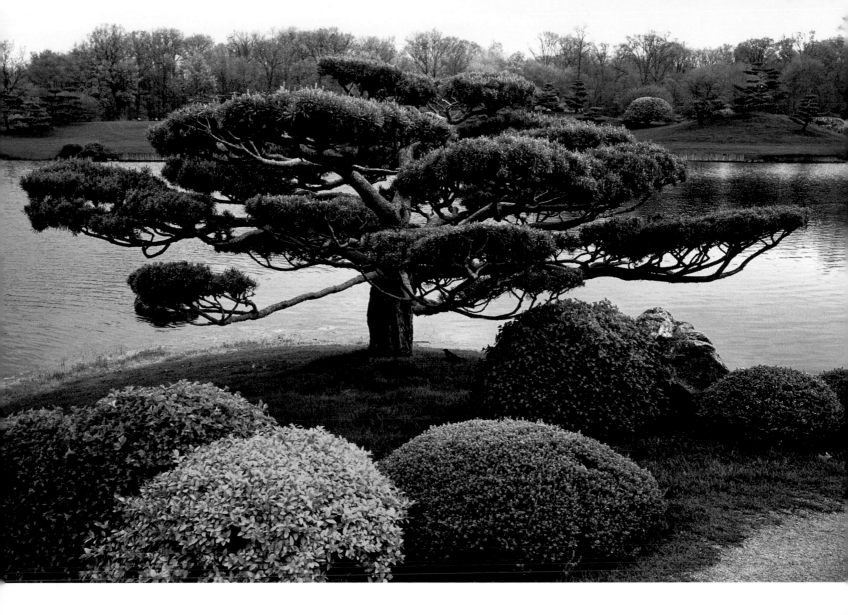

lanterns mark the way, while the zigzag bridge ensures evil spirits will not follow, since they travel only in a straight line.

Shoin House, modeled after a samurai's retreat, was built in Japan using traditional carpentry techniques—no nails are used in the construction. A serene moss garden leads to the structure, which is open for viewing during the growing season. Inside the building a magnificent view across the lake encourages contemplation, harmony and reverence for nature.

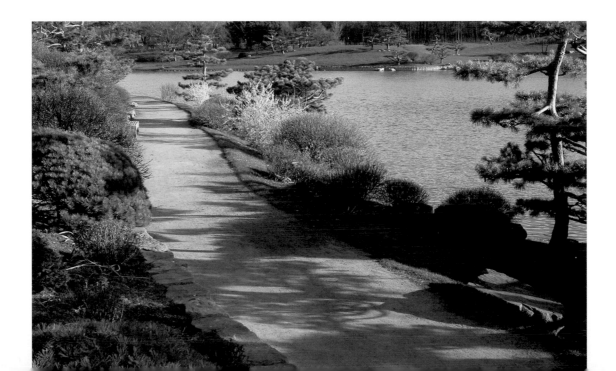

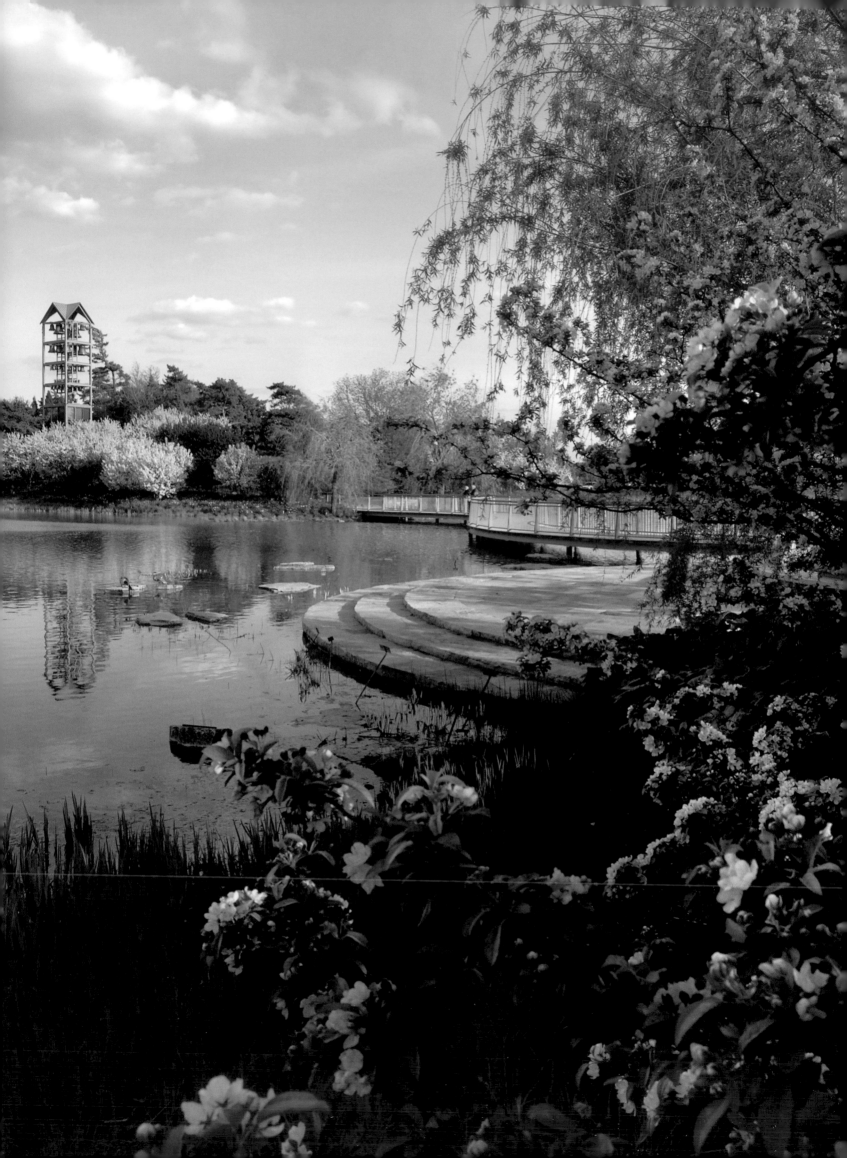

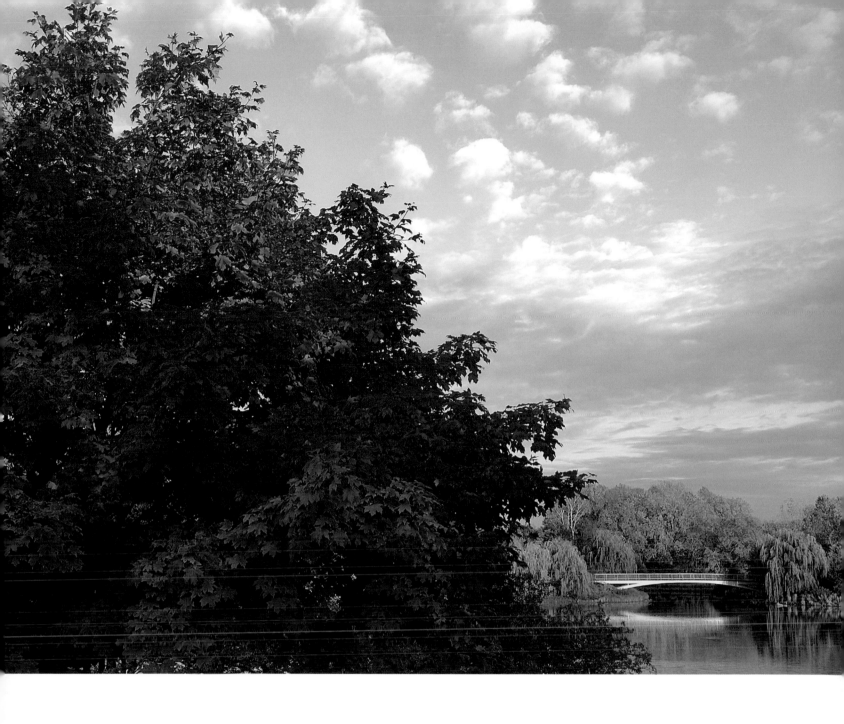

GARDENS OF THE GREAT BASIN The magnificent gardens framing the Great Basin form a flowering necklace whose images are mirrored in the waters of the central lake. On the west bank, cool-color plantings reflect the sunrise; on the east bank, hot-color plantings reflect the setting sun and the warmer afternoon temperatures. From every pathway are long vistas and intimate glimpses of water plants, perennials, flowering bulbs, grasses, trees and shrubs—all landscaped around a 16-million-gallon lake.

Water Gardens fill the curves of the lake with 50,000 hardy water lilies, lotuses, native grasses and sedges. Lakeside Gardens include plants known for hardiness, beauty and their ability to stabilize erosion. They are but one component of a healthy lake system, which also includes communities of fish, turtles, frogs and flocks of migrating and resident water birds.

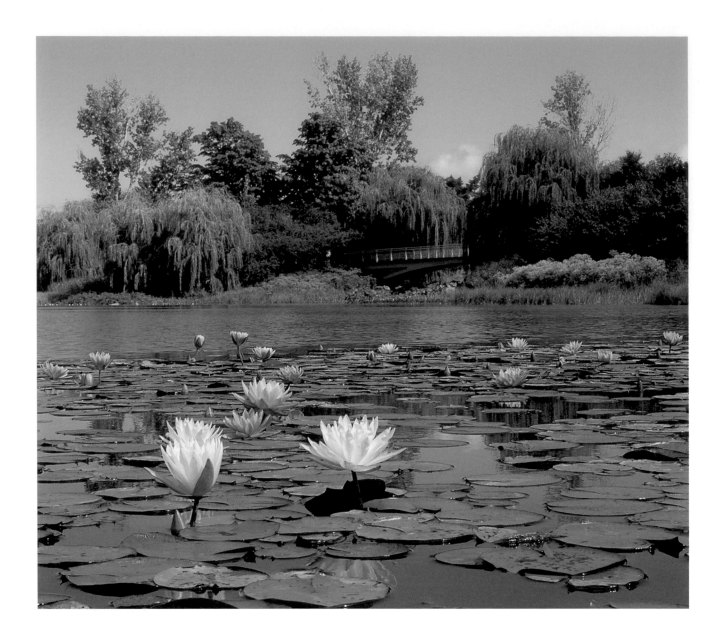

The north-facing gardens of Evening Island complete the central ring of terraced gardens, with the two connecting bridges—the Arch and the Serpentine—closing the circle. The sequential blooming of 300 pink and white crabapple trees marks a signature springtime moment at the Garden. The draining of the Great Basin, and the engineering and completion of these shoreline gardens, was one of the largest construction projects in the Garden's history.

Overlooking Lakeside Gardens is Martin Puryear's magnificent untitled granite sculpture, 1998, one of a pair of garden seats; the other sculpture is constructed of stainless steel.

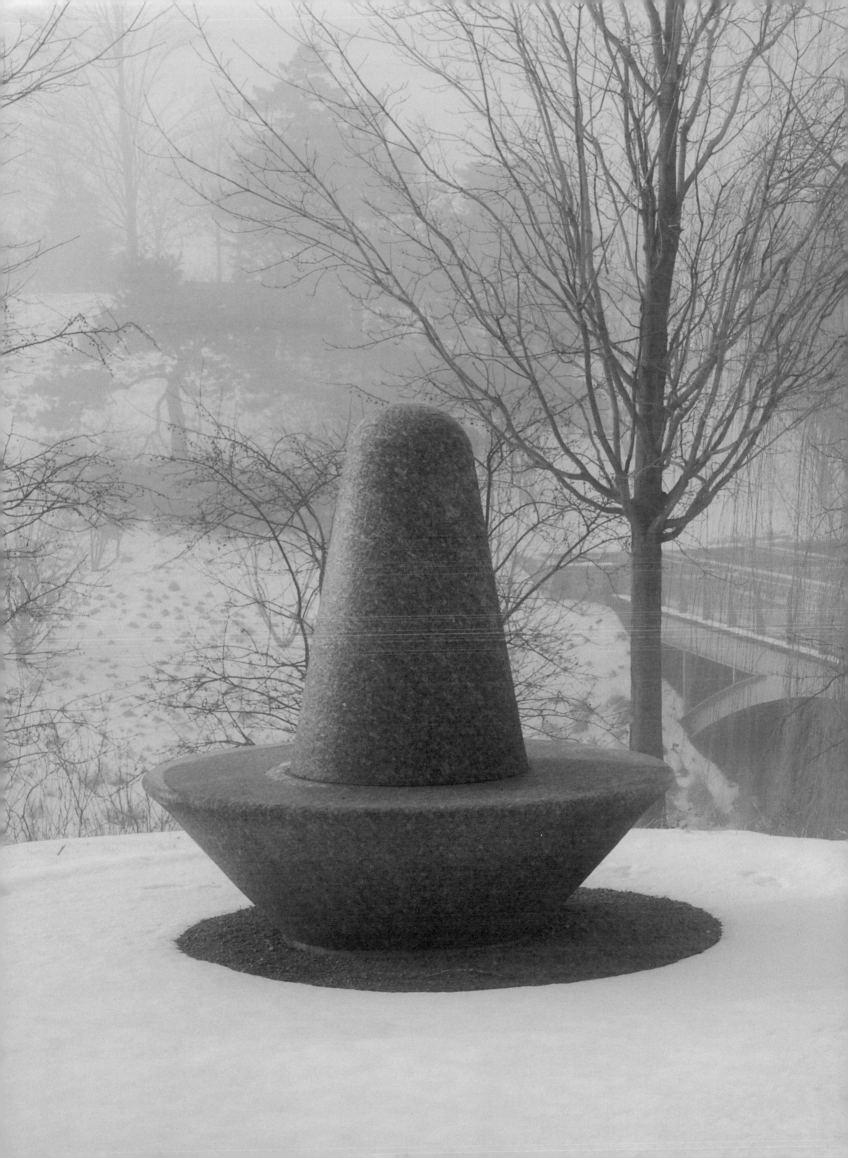

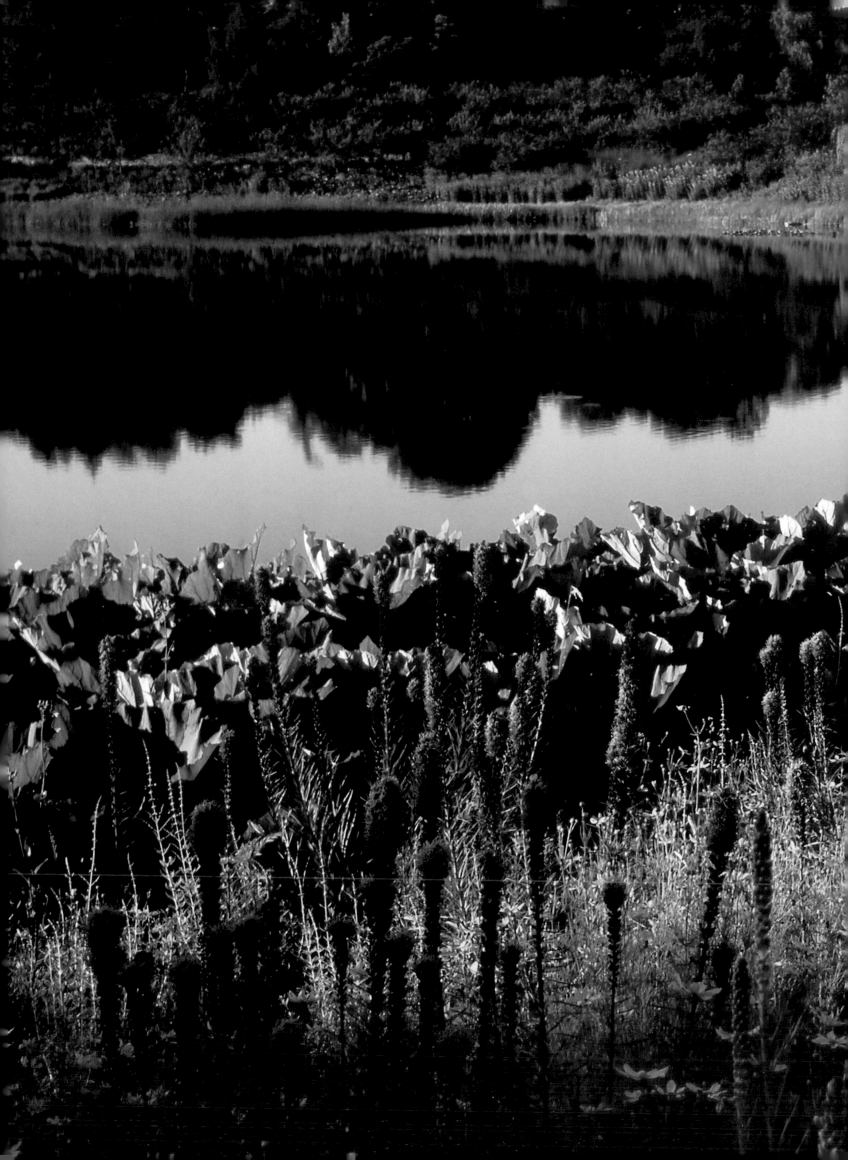

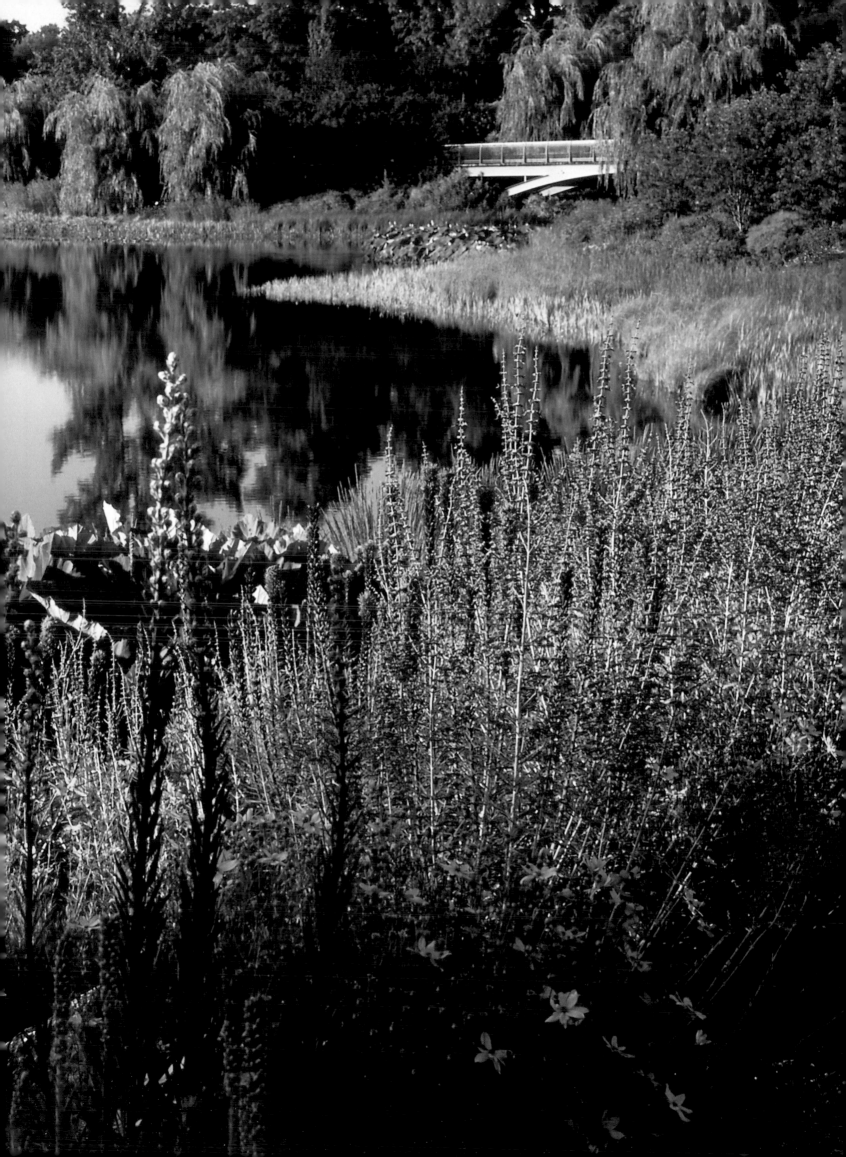

EVENING ISLAND Occupying a place of honor across the central lake is Evening Island, designed by Oehme, van Sweden & Associates, pioneering landscape architects who championed the New American Garden style, which blends carefully designed "hardscape"—walls, terraces and other built features—with layered masses of foliage and flowering plants chosen for their ease of maintenance and year-round beauty. Evening Island connects the more intensely cultivated display gardens to the north with the naturalistic Prairie to the south.

Joined to Main Island by two distinctive bridges, the Arch and the Serpentine, this five-acre garden is a living tapestry of texture and color, with grand sweeps of flowering plants and grasses. Plants were selected for color, long-lasting ornamental appeal, kinetic qualities and dramatic impact when massed.

Beautifully illuminated by night, Evening Island hosts hand-played bell concerts from Butz Carillon on summer evenings and spectacular sunsets in all seasons.

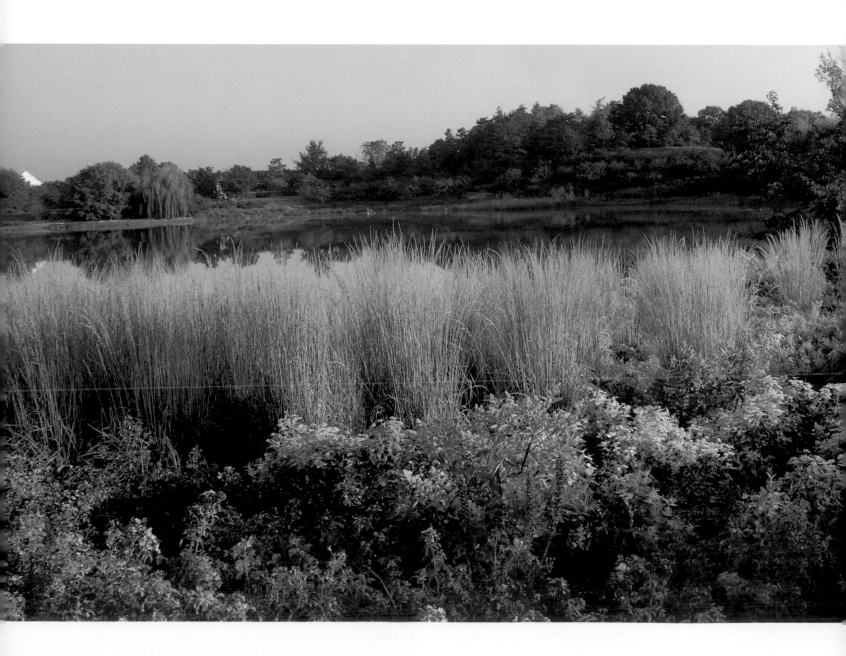

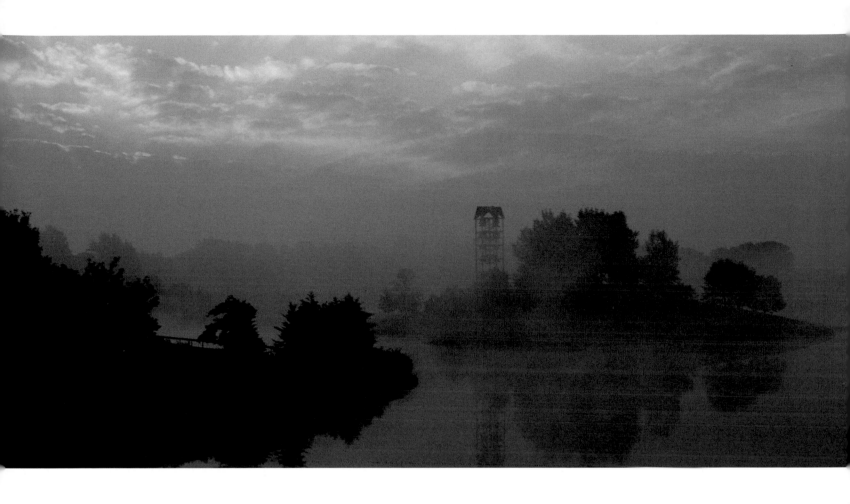

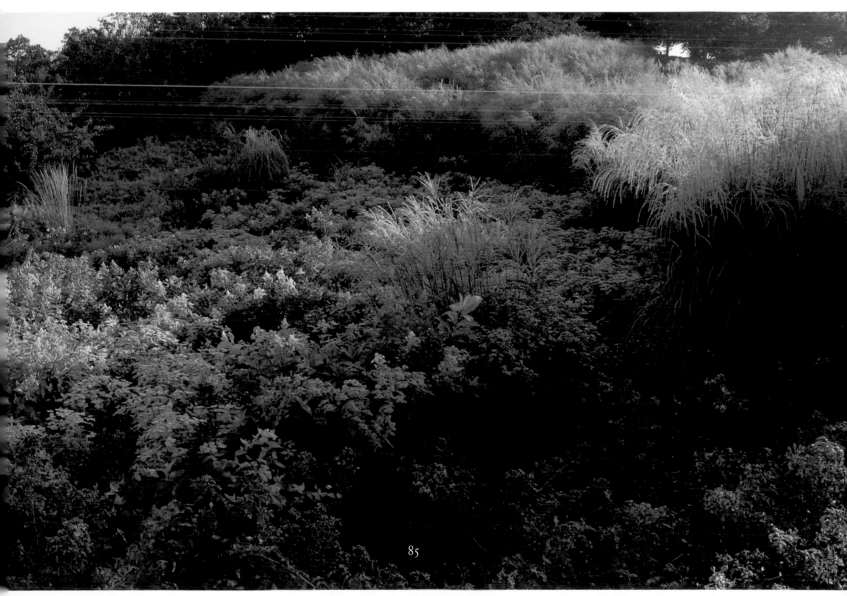

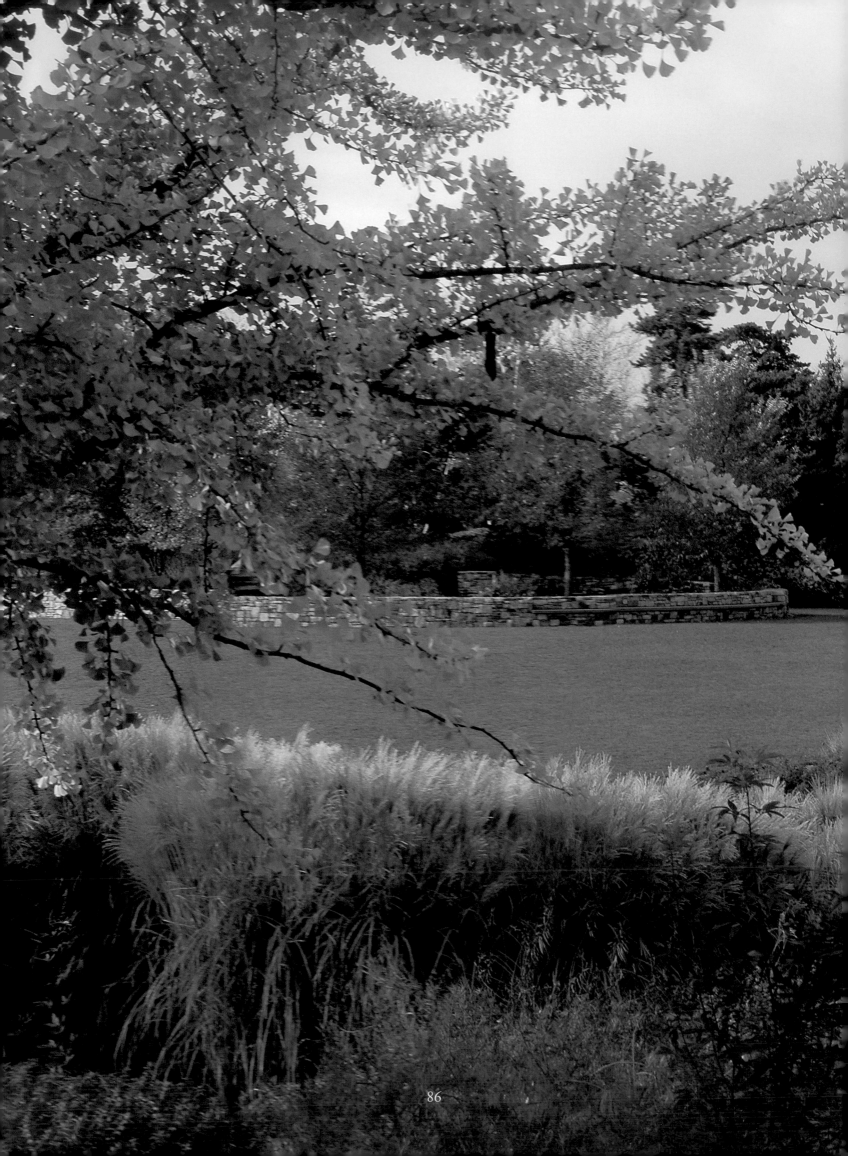

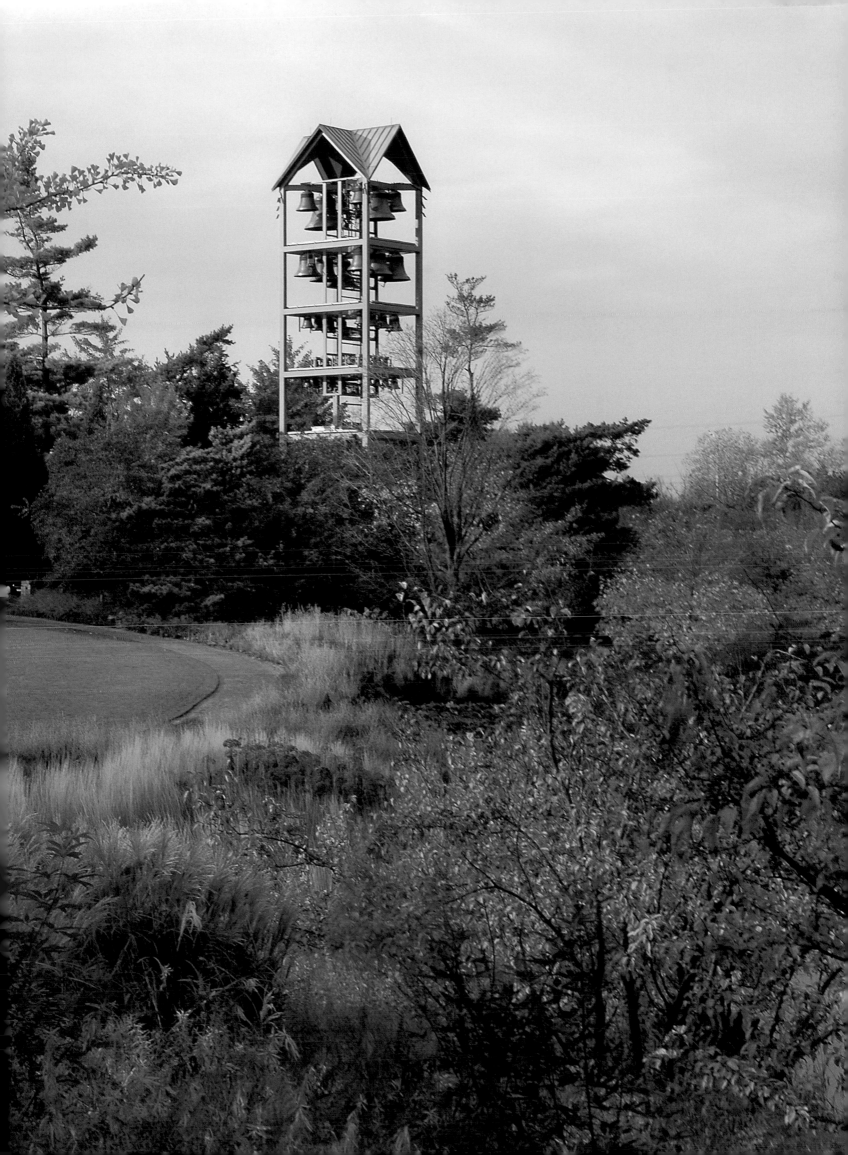

LAVIN PLANT EVALUATION GARDEN Research and science, central to the Chicago Botanic Garden's mission, often remain unseen. Lavin Plant Evaluation Garden offers visitors who venture to the Garden's south end a firsthand opportunity to walk through a beautiful, living garden laboratory that overflows each year with 7,000 sun-loving perennials, flowering shrubs, ground covers and vines. These plants are grown side by side, closely monitored for five or more years, and then carefully evaluated to see which can be recommended for Midwestern gardens. Research results are published in the Garden's highly regarded Plant Evaluation Notes. This garden is also home to the Chicago Botanic Garden's perennial plant breeding program, in which new hybrid plants displaying outstanding color, fragrance and durability are developed for Midwestern gardeners. These important Garden programs are successful examples of how a scientific institution can share its research with the gardening public.

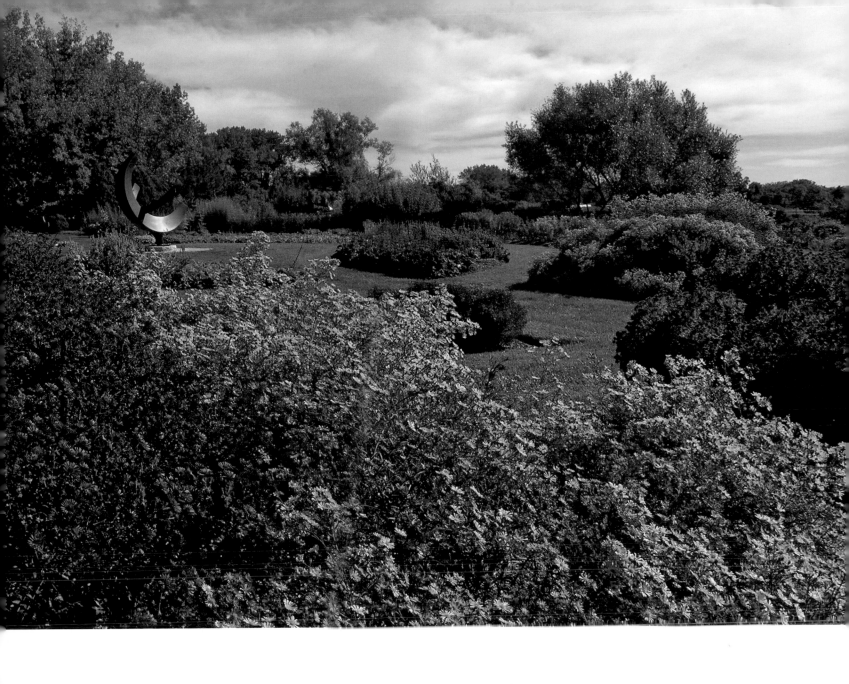

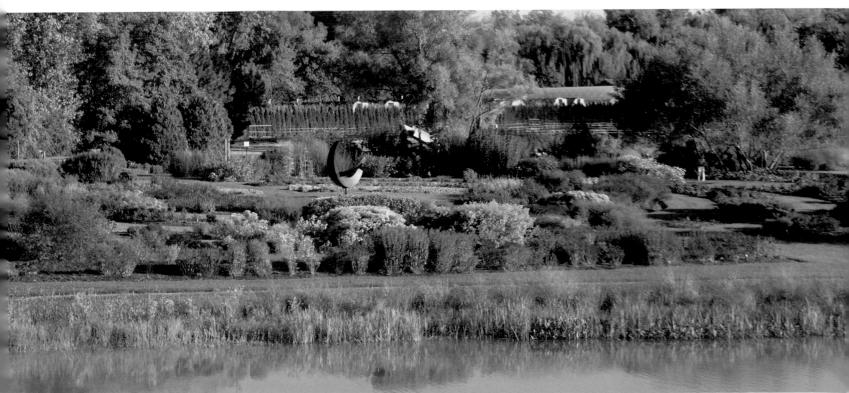

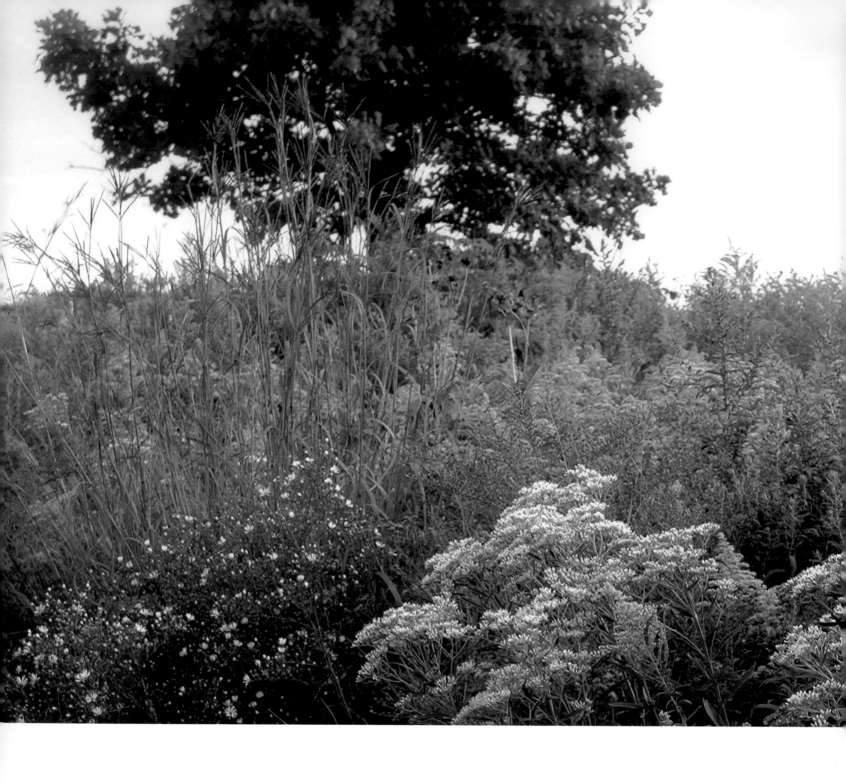

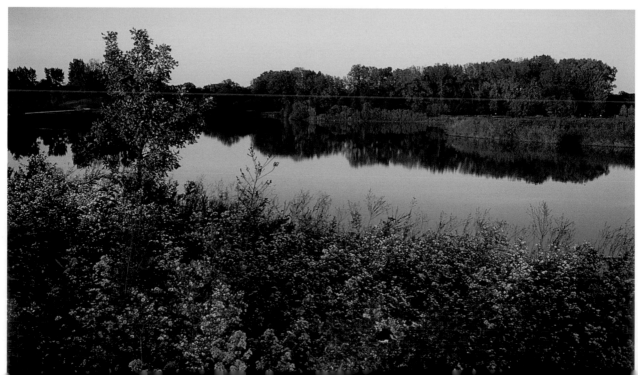

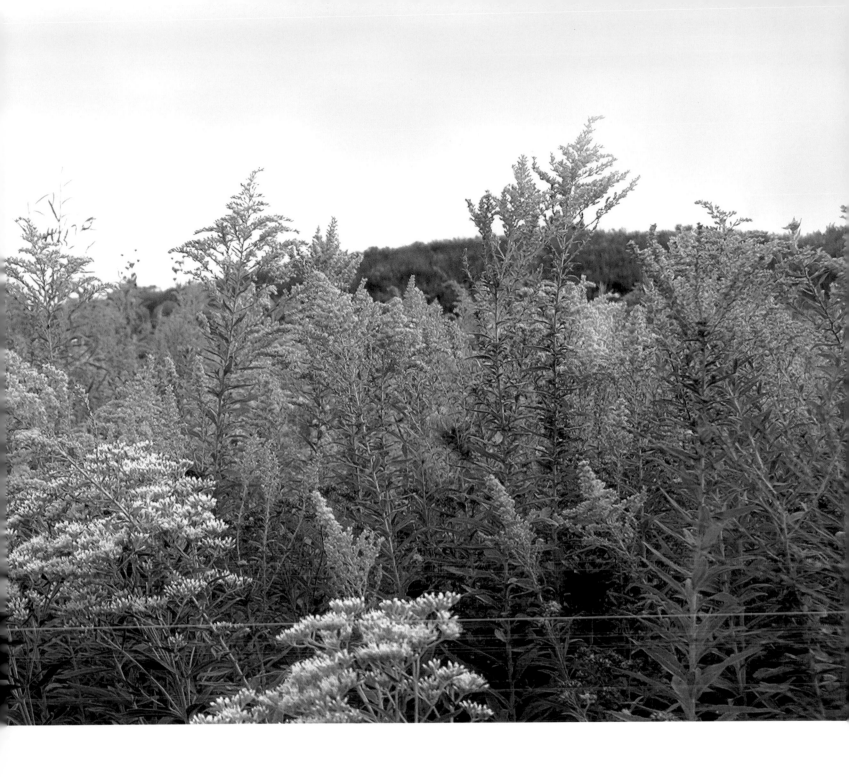

DIXON PRAIRIE The prairie represents the heritage of northern Illinois. It provides a Midwestern sense of place and a view of the past. In Dixon Prairie, visitors have a chance to walk through history, seeing and touching what early Americans experienced before populations increased, cities were born and Illinois prairies succumbed to the plow.

There are six distinct prairie re-creations in Dixon Prairie—each with its own unique landform, plant communities and soil composition—all once common in northeastern Illinois. Visitors can walk through a mesic or tallgrass prairie, a gravel hill prairie, a fen, a sand prairie, a savanna and a wet prairie, drawing inspiration and wonder from the complexity of nature and seasonal changes in color and texture.

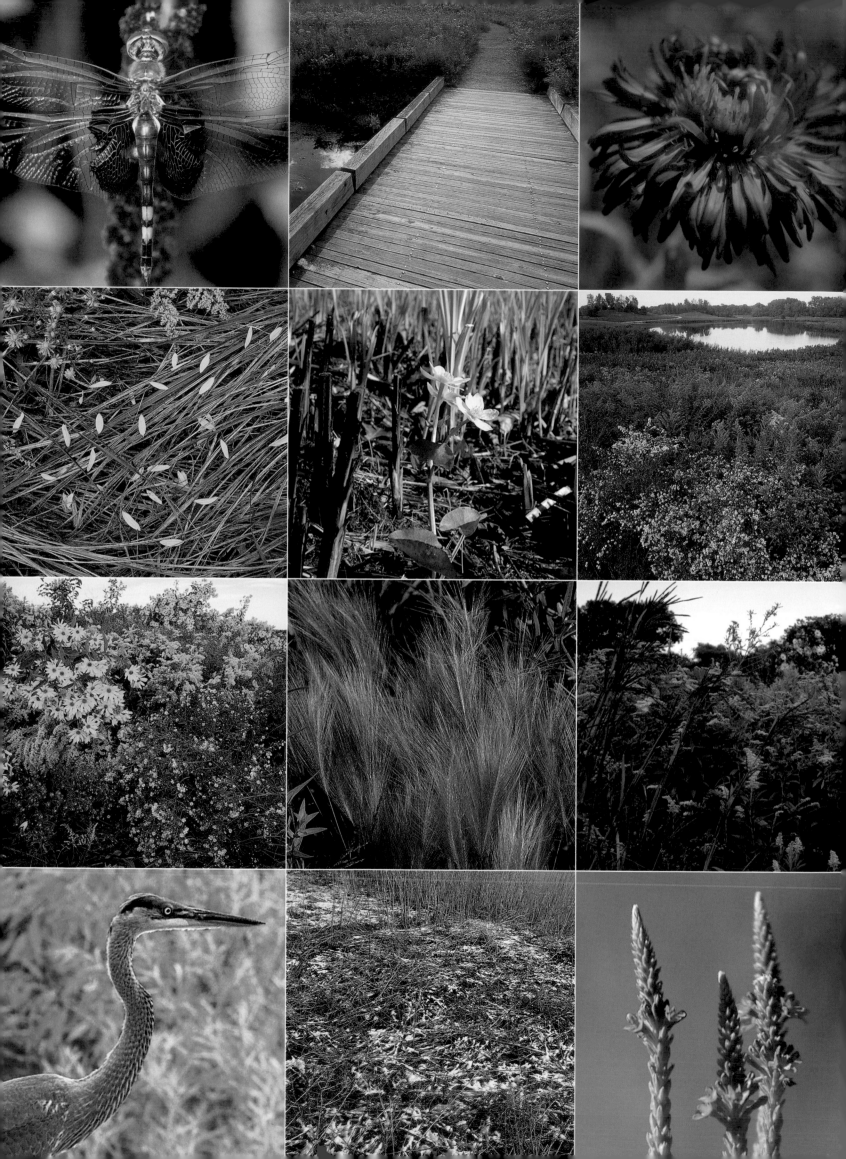

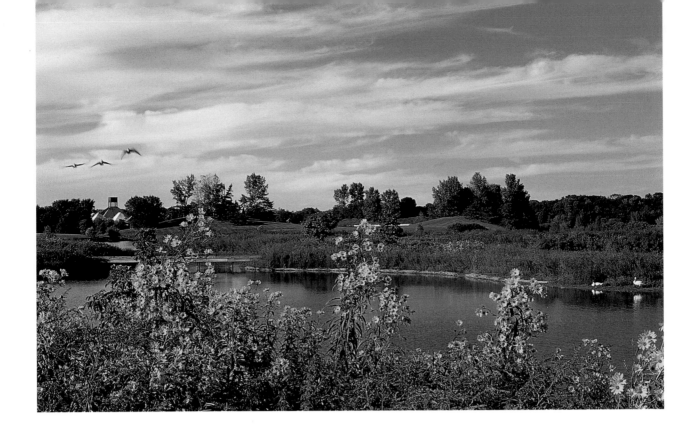

MARSH ISLAND As part of the larger Dixon Prairie, Marsh Island features three of the six different prairie types re-created at the Garden. Much of the island, both along the shoreline and in the interior, is wet prairie; lovely plants like meadow anemone and New England aster thrive here. There are patches of savanna prairie with stands of bur oak, false sunflower and golden Alexander, and throughout the island are remnants of tallgrass prairie, with the towering plants iconic to this habitat. The protected, watery cove formed by the island's C-shape is a favorite resting and feeding place for waterfowl and migrating ducks.

Prairies develop over thousands of years. As the Garden's land managers plant, weed, burn and collect seed from these 15 acres of prairie, they pay respect to the past—and the Garden dedicates itself once again to the conservation of the future and ensures that generations to come will enjoy and learn from these threatened environments.

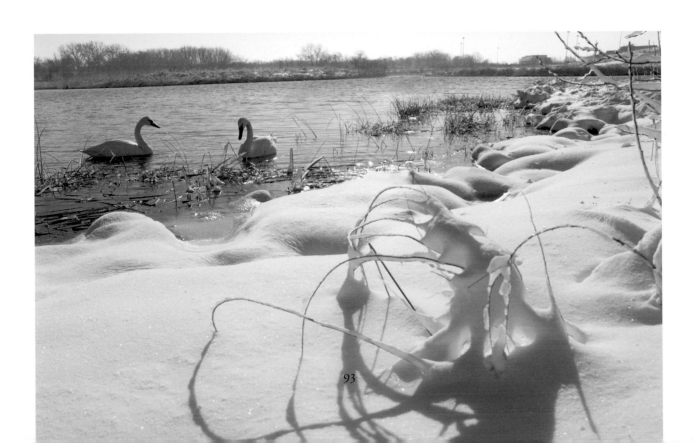

CHICAGO INCORPORATES, WITH THE MOTTO "URBS IN HORTO"—CITY IN A GARDEN.

1837

1838

WILLIAM TURNBULL PURCHASES GRAZING LAND IN GLENCOE FOR $1.25 AN ACRE. PART OF THIS LAND WILL EVENTUALLY BECOME THE CHICAGO BOTANIC GARDEN.

A GARDEN TIMELINE

THE CHICAGO WORLD FLOWER AND GARDEN SHOW OPENS. THE SOCIETY PARTICIPATES THROUGH 1979.

1943

1961

1959

THE HORTICULTURAL SOCIETY RECHARTERS AS THE CHICAGO HORTICULTURAL SOCIETY.

THE SOCIETY ENDORSES THE FOUNDING OF A "GREAT HORTICULTURAL CENTER" FOR CHICAGO AND SOON IDENTIFIES A SITE TO LEASE IN GLENCOE.

THE CHICAGO BOTANIC GARDEN OPENS TO THE PUBLIC. NEW GARDENS WILL OPEN ALMOST EVERY YEAR, AND PROGRAMS WILL EXPAND EXPONENTIALLY.

1986

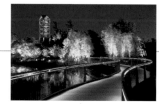

1972

THE GARDEN IS ACCREDITED BY THE AMERICAN ASSOCIATION OF MUSEUMS. IT ALSO FORMS CHICAGOLAND GROWS®, INC.

GARDEN MEMBERSHIP REACHES 20,000; VISITORS TOTAL 750,000.

1995

1994

COLLECTIONS 2000, A SERIES OF PLANT-COLLECTING TRIPS, IS LAUNCHED.

JAPANESE BONSAI MASTER SUSUMU NAKAMURA DONATES 19 PRIZED SPECIMENS TO THE GARDEN, BRINGING ITS COLLECTION TO WORLD-CLASS STATUS.

2002

2000

MEMBERSHIP REACHES 47,500, MAKING THE GARDEN THE LARGEST OF ANY BOTANIC GARDEN IN THE UNITED STATES. THE LIBRARY ACQUIRES OVER 4,000 RARE BOOKS AND JOURNALS FROM THE MASSACHUSETTS HORTICULTURAL SOCIETY.

VISITORS TOTAL MORE THAN 800,000. THE GARDEN, IN COLLABORATION WITH 17 PARTNERS, LEADS THE DEVELOPMENT OF PLANTCOLLECTIONS™, A NATIONAL DATABASE OF PLANT RECORDS.

2004

2006

2005

THE GARDEN RECEIVES THE NATIONAL AWARD FOR MUSEUM SERVICE FROM THE INSTITUTE OF MUSEUM AND LIBRARY SERVICES.

THE NEWLY RENOVATED REGENSTEIN CENTER OPENS.

DR. JOHN KENNICOTT, EDITOR OF THE
"PRAIRIE FARMER," URGES CHICAGO TO
ACQUIRE 300 ACRES OF WOODLAND
FOR PARKS AND A GARDEN.

THE HORTICULTURAL SOCIETY
OF CHICAGO PARTNERS WITH THE
ART INSTITUTE. IT HOLDS FLOWER
SHOWS AND LECTURES AT THE
ART INSTITUTE THROUGH 1918.

1890

1853

1908

THE HORTICULTURAL SOCIETY OF CHICAGO IS
CHARTERED. ITS GOAL IS "ENCOURAGEMENT AND
PROMOTION OF THE PRACTICE OF HORTICULTURE
IN ALL ITS BRANCHES AND THE FOSTERING OF
AN INCREASED LOVE OF IT AMONG THE PEOPLE."

THE STATE AUTHORIZES THE SOCIETY'S
LEASING OF FOREST PRESERVE DISTRICT
LAND IN GLENCOE. THE PLAN IS APPROVED
BY THE COOK COUNTY BOARD OF SUPER-
VISORS TWO YEARS LATER.

1965

1963

THE SOCIETY BREAKS GROUND FOR THE CHICAGO
BOTANIC GARDEN ON 300 ACRES OF FOREST PRESERVE
DISTRICT LAND. OVER THE NEXT SEVEN YEARS, IT
WILL TRANSFORM THE MARSHY SKOKIE FLOOD PLAIN
INTO A DISTINCTIVE GARDEN WITH NINE ISLANDS.

THE CHICAGO HORTICULTURAL SOCIETY CELEBRATES
ITS 100TH ANNIVERSARY AND THE 25TH ANNIVERSARY
OF THE GARDEN'S GROUNDBREAKING.

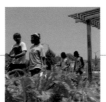

1993

1990

THE GARDEN JOINS WITH FOUR OTHER GARDENS TO
FORM THE MIDWEST PLANT COLLECTING COLLABORATIVE
TO INCREASE THE VARIETY OF ORNAMENTAL PLANTS
AVAILABLE IN THE MIDWEST.

THE GARDEN JOINS WITH 33 PARTNERS TO
FOUND THE CHICAGO WILDERNESS CONSORTIUM,
TO PROTECT AND RESTORE THE NATURAL
ECOSYSTEMS OF THE CHICAGO REGION.

THE SCHOOL OF THE CHICAGO
BOTANIC GARDEN OPENS.

1999

1996

1997

THE GARDEN CELEBRATES
THE OPENING OF THE BUEHLER
ENABLING GARDEN, DEDICATED
TO ACCESSIBLE GARDENING FOR
PEOPLE OF ALL ABILITIES. IT IS
THE PREEMINENT GARDEN OF
ITS KIND IN THE UNITED STATES.

THE GARDEN'S COLLECTION OF LIVING PLANTS REACHES
TWO MILLION. IT JOINS THE ROYAL BOTANIC GARDENS,
KEW, IN THE MILLENNIUM SEED BANK PROJECT TO PRESERVE
SEEDS FROM 10 PERCENT OF THE WORLD'S FLORA.

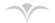

2003

2003

THE GARDEN INTRODUCES GREEN YOUTH FARM,
A SUMMER HIGH SCHOOL APPRENTICESHIP
PROGRAM THAT FOSTERS INTEREST IN HORTICULTURE,
AGRICULTURE AND GREEN ENTREPRENEURSHIP.

THE CHICAGO BOTANIC GARDEN CELEBRATES
35 YEARS OF BEING OPEN TO THE PUBLIC.

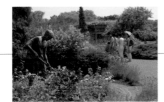

2006

2007

THE GARDEN RECEIVES THE HORTICULTURE
MAGAZINE AWARD FOR GARDEN EXCELLENCE
FOR 2006, PRESENTED AT THE AMERICAN PUBLIC
GARDENS ASSOCIATION ANNUAL CONFERENCE.

CHICAGO BOTANIC GARDEN

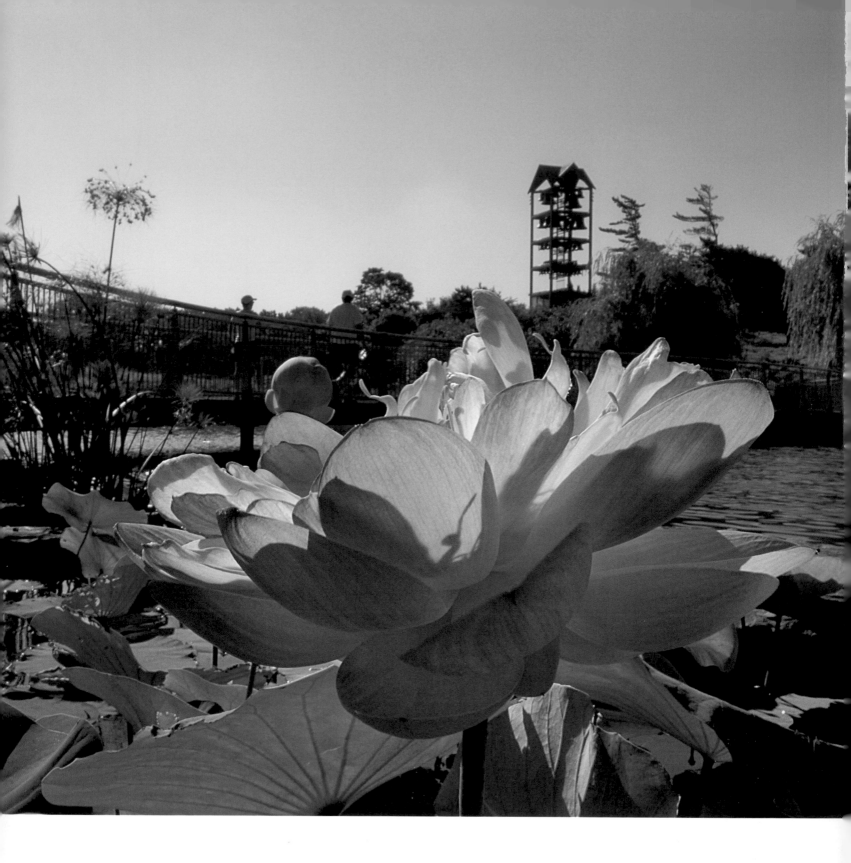

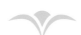

CHICAGO BOTANIC GARDEN

1000 Lake Cook Road, Glencoe, Illinois 60022

www.chicagobotanic.org • 847-835-5440